BRIGHTON
THROUGH TIME
A Second Selection
Judy Middleton

AMBERLEY PUBLISHING

Acknowledgements

Thanks to Debbie of the Hilton Metropole Hotel, Fernando of the Royal Albion Hotel and Jo Fuller of Portslade for assistance in taking photographs from high places!

First published 2011

Amberley Publishing
The Hill, Stroud
Gloucestershire, GL5 4EP

www.amberley-books.com

Copyright © Judy Middleton, 2011

The right of Judy Middleton to be identified as the Author of this work has been asserted in accordance with the Copyrights, Designs and Patents Act 1988.

ISBN 978 1 4456 0198 4

British Library Cataloguing in Publication Data. A catalogue record for this book is available from the British Library.

Typeset in 9.5pt on 12pt Celeste.
Typesetting by Amberley Publishing.
Printed in the UK.

Introduction

Just when I thought my days of compiling books were over, along comes the invitation from Amberley Publishing to produce a volume for their *Through Time* series. My initial reaction was to turn it down – been there, done that. But then I had second thoughts because of the novel use of colour. Indeed, the experience of working on the two books (one on Hove and Portslade, the other on Brighton, both published in 2009) was so worthwhile that I was bold enough to consider a second volume on Brighton.

I am well aware that Douglas d'Enno produced *East Brighton and Ovingdean* in this series in 2010, but there is so much scope in a place like Brighton that we are not treading on each other's toes. On the contrary the books are complementary.

The postcards come from my own collection, built up over many years with some recent additions purchased especially for this book from Robert Jeeves of *Step Back in Time*.

The camera I used was a simple digital model that can be surprisingly useful in taking quick shots of crowded scenes.

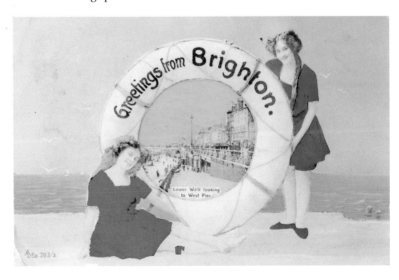

Bibliography

The *Argus*

Beevers, David & Roles, John: *A Pictorial History of Brighton* (1993)

Berry, Sue: *Georgian Brighton* (2005)

Carder, Timothy: *The Encyclopaedia of Brighton* (1990)

Collis, Rose: *The New Encyclopaedia of Brighton* (2010)

Collis, Rose: *Brighton Boozers* (2005)

Elliott, AG: *A Portrait of Brighton in Tram Days* (1986)

Gray, Frank: *Walking on Water. The West Pier Story* (1998)

Horlock, *Christopher: Brighton, the Century in Photographs* (2001)

Horlock, Christopher: *Brighton & Hove, Then and Now. Volume 1* (2001)

Horlock, Christopher: *Brighton & Hove, Then and Now. Volume 2* (2003)

Middleton, Judy: *Encyclopaedia of Hove & Portslade* (2001–2003)

Roberts, John: *British Bus Systems, Number 4.* Brighton, Hove & District (1984)

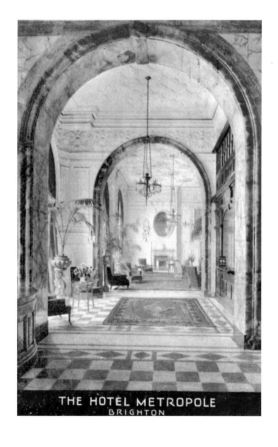

THE HOTEL METROPOLE
BRIGHTON

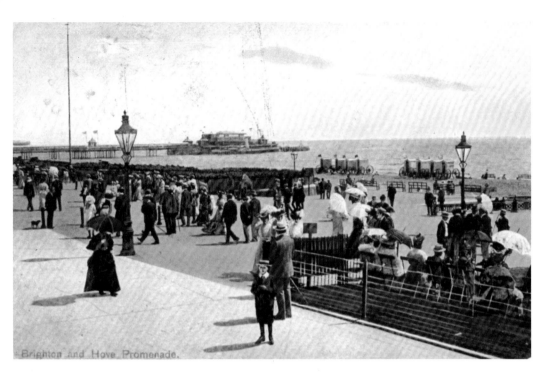

Brighton and Hove Promenade.

Where Hove Ends and Brighton Begins

Before the Peace Statue was erected, this was the view of the border area, with the enclosed lawn being in Hove. Brunswick Lawns was a favourite place for promenading or watching the world go by. Nowadays the lawns are often used to stage special events, such as the Food Fair taking place here on 23 May 2010. In the background Embassy Court, Brighton, looms over Brunswick Terrace, Hove.

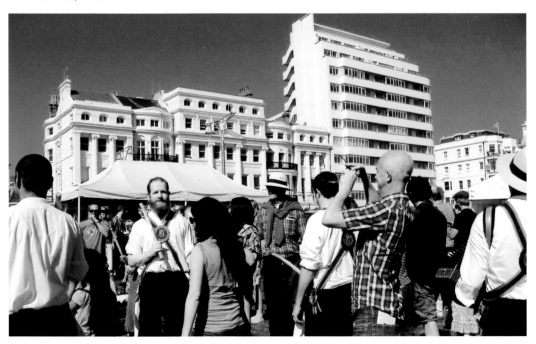

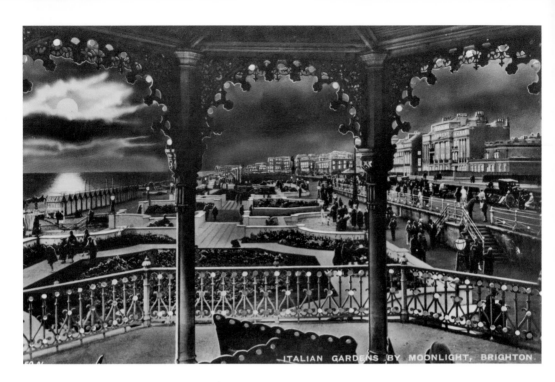

ITALIAN GARDENS BY MOONLIGHT, BRIGHTON.

View from the Bandstand

The old photograph was hand-coloured for dramatic effect and included a huge moon. The view looks westward from the bandstand towards Hove and features the sunken gardens. The recent photograph reveals the delicate tracery of the recently restored ironwork. The gardens have gone, while Embassy Court is seen to the right.

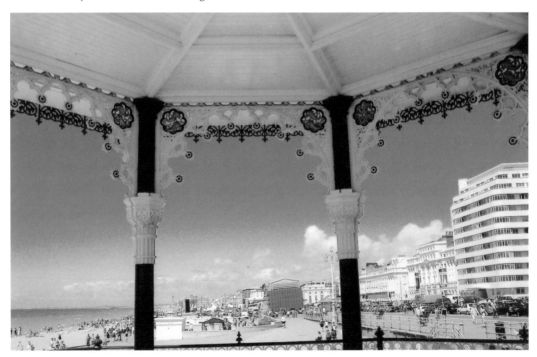

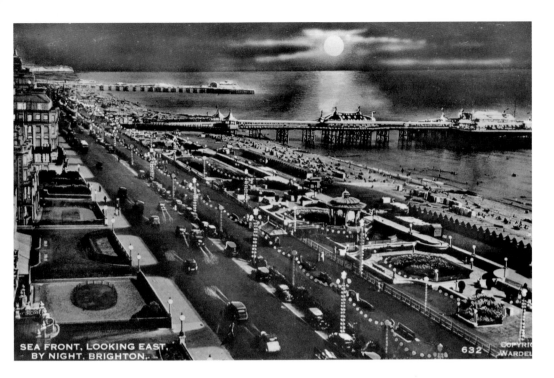

SEA FRONT, LOOKING EAST,
BY NIGHT, BRIGHTON.

632

Seafront Angles

Although a different publisher produced this postcard, the treatment is similar to the previous one. It is amusing to note that the colour applied to the tops of cars does not always reflect the colour of the lamp above. Other points of interest are the two piers in their heyday, and the gardens belonging to seafront properties on the left. In the modern view a small seafront shop provides a blaze of colour.

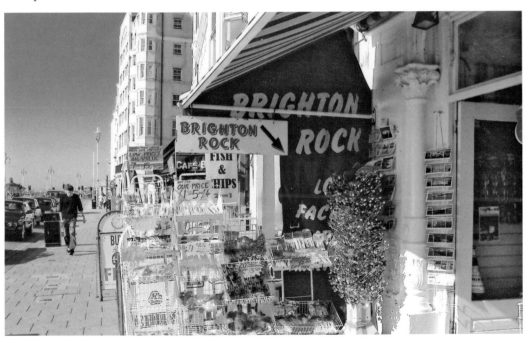

7

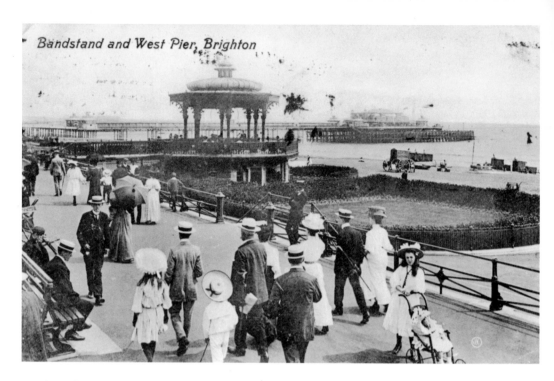

Bandstand and West Pier, Brighton

Bandstand and West Pier

This view of people promenading near the bandstand was posted in 1910. Panama hats are much in evidence and the children are dressed in the height of Edwardian fashion. The bandstand has been recently restored and emerged from its boards and scaffolding in 2009. In 2010, the bandstand was licensed as an official wedding venue.

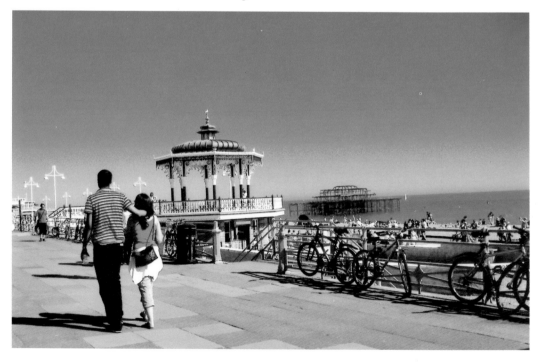

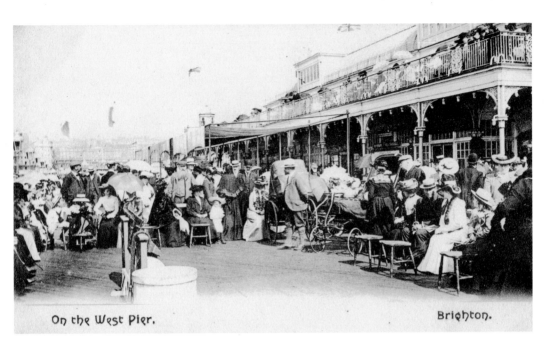

On the West Pier. Brighton.

The West Pier

Many local people will be struck with nostalgia when they seen this wonderful image of bustling life on the West Pier on a sunny day. The ironwork in the background seems remarkably similar to that used in the bandstand. The close-up view demonstrates this, while all that is left of the West Pier rusts in the background.

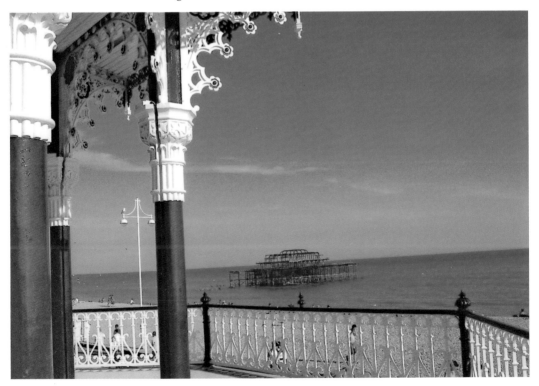

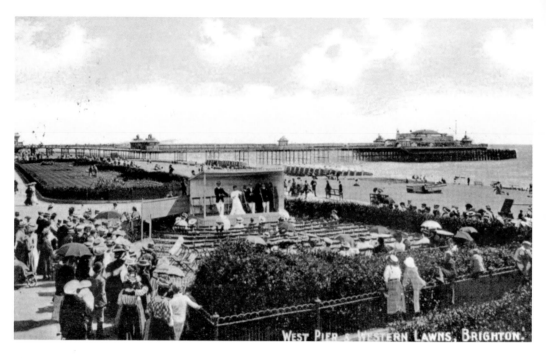

Live Entertainment

A walk along the promenade was often enlivened by the performance of al fresco entertainment, although in this case the artists enjoyed the protection of a portable stage. The tradition continues and this group serenaded the public on a bright but chilly day in February 2009.

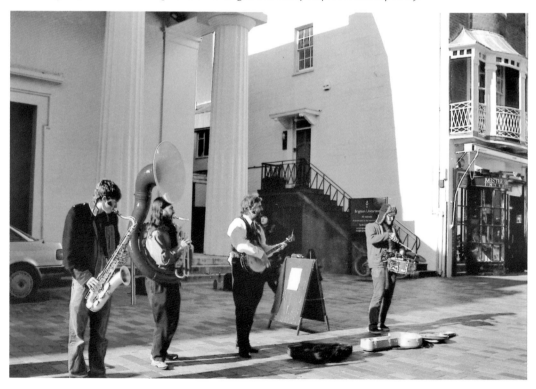

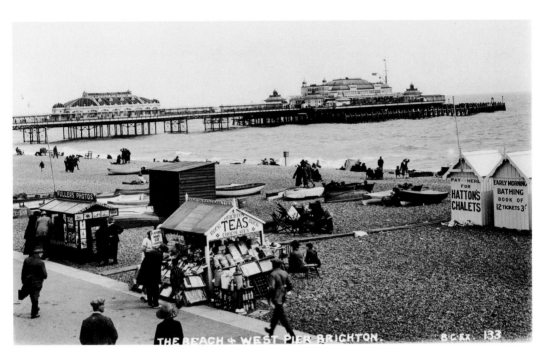

West Pier and Beach

The full extent of the West Pier in its glory days is clearly seen in this postcard. The kiosk sold teas as well as Brighton rock, chocolates and cigarettes and, beyond it, the small enterprise was known as Fuller's Photos. To the right, early morning bathing from Hatton's chalets cost 3/- for a book of 12 tickets. The second picture features a market, set up on the beach near the pier in May 2010.

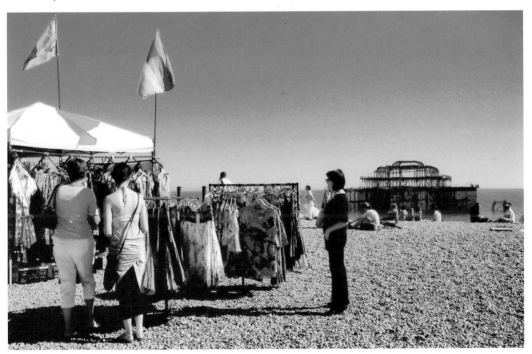

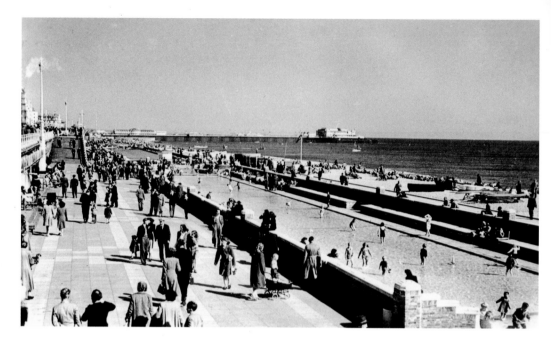

Paddling Pools

The old paddling pool dates from the 1930s and, apart from the war years, it remained in use until the 1990s. It was a long, narrow strip and the modern paddling pool could not be more different. It is also smaller and sited further east in the children's playground.

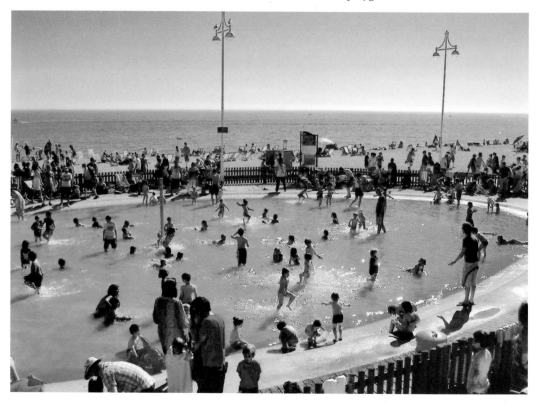

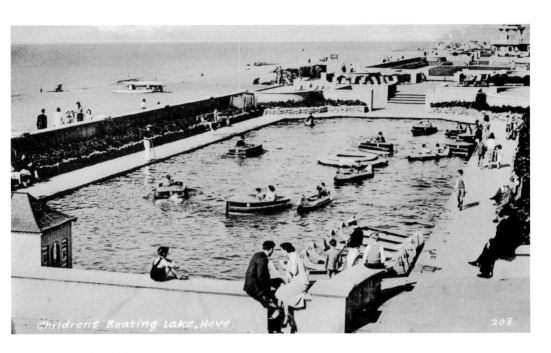

Childrens Boating Lake, Hove. 203.

Boats and Bubbles

The postcard is captioned as a 'children's boating lake', which is quite an impressive description for a modest feature. It did, however, provide much amusement and it was created in 1925. Note the nautical-looking man with his long pole and hook keeping watch on the south side. In July 2010, children could enjoy a novel experience moving over the water inside a giant bubble.

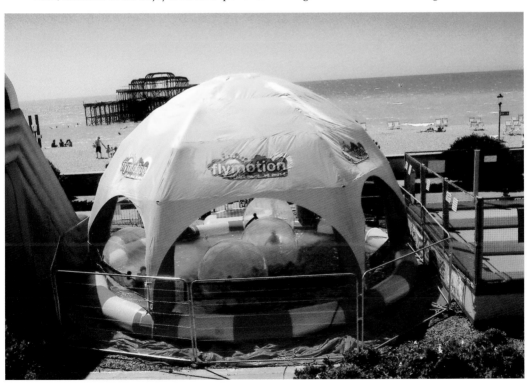

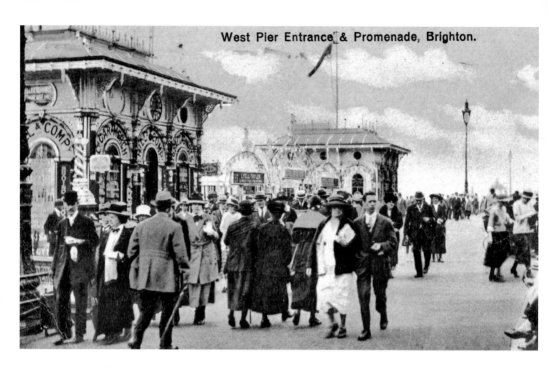

West Pier Entrance & Promenade, Brighton.

Picturesque Kiosks

The structures on either side of the entrance to the West Pier could hardly be called modest buildings, as every plane and angle is decorated in high seaside style. The notice between them advertises Mr Lyell-Tayler and the West Pier Orchestra that he conducted from 1918 to 1921. It was best not to arrive late at his concerts because it made him angry. The modern photograph reveals the sorry state of one of the kiosks in May 2010.

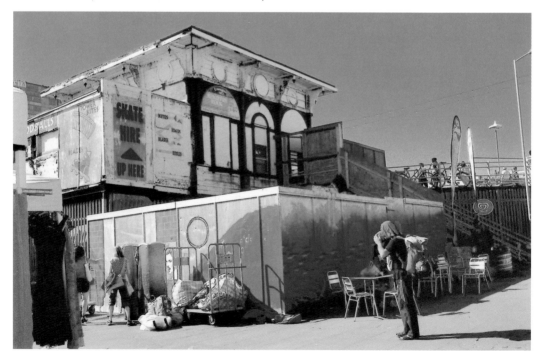

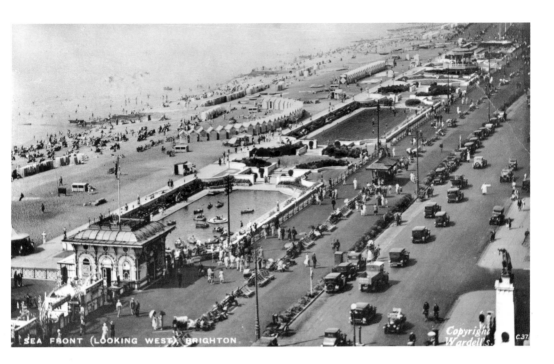

SEA FRONT (LOOKING WEST), BRIGHTON

View from the Metropole

The old view dating from the 1930s shows one of the kiosks and the boating pool. Note the beach huts arranged in a semicircle in the background, and the policeman in white coat on point duty in King's Road. The second photograph was taken from the Chartwell Suite, on the seventh floor of the Hilton Metropole, in October 2010. It reveals a depressed area awaiting redevelopment with the iron posts being literally the last legs of the West Pier.

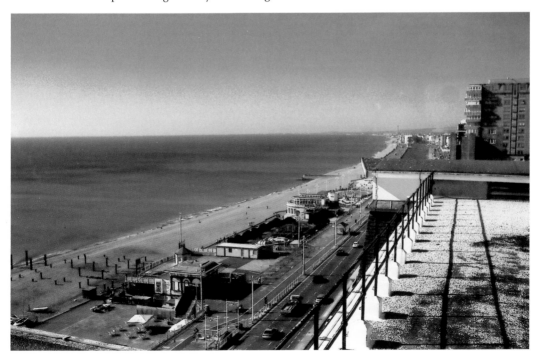

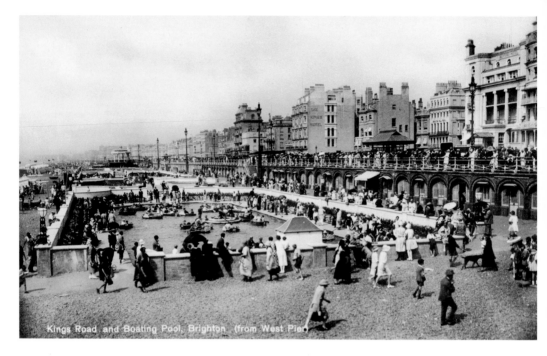

Kings Road and Boating Pool, Brighton (from West Pier)

View from the West Pier

The photographer was standing on the West Pier in the 1920s when he took this fine prospect looking west. On the right is the Bedford Hotel and the boating pool is the centre of attention. The sender of the postcard announces that they are having a 'ripping time'. The recent photograph was taken from a walkway leading to a café and looks out over the children's playground.

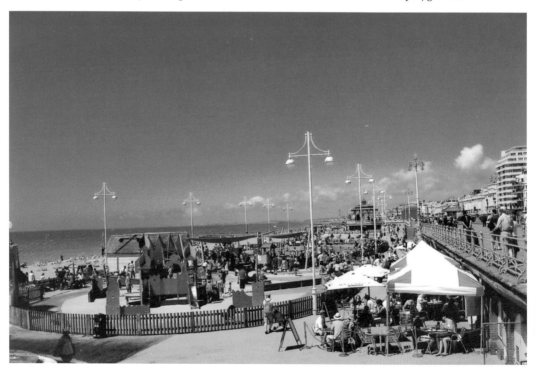

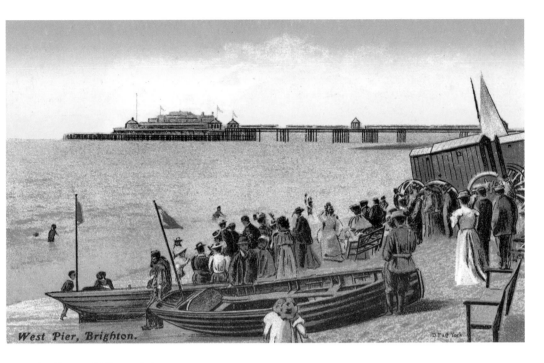

West Pier, Brighton.

D.F. & Co York

An Unusual Viewpoint

The majority of old postcards featuring the West Pier were taken from the west, whereas this one was photographed from the east. The pier looks strangely empty too. This is because the central concert hall was not added until 1916. The recent view is a tribute to the old-time builders because, despite storms, fires, relentless battering from the sea and years of neglect, part of it still survives.

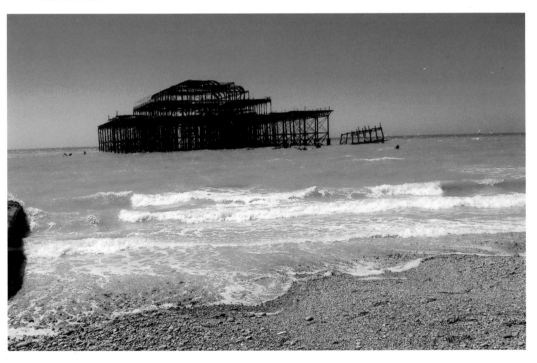

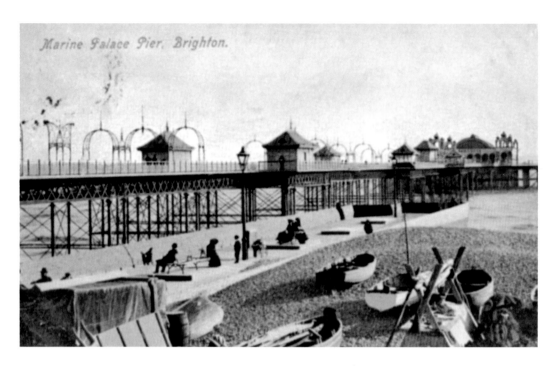

Palace Pier

When this view was taken in 1906, the Palace Pier still lacked its central Winter Garden, the building not being constructed until 1910–1911. The concrete groyne was built originally in 1876, but it was made wider in 1896 to accommodate an enlarged storm water outlet. The second view was taken further west and shows the second groyne, together with a piece of artwork at the end known popularly as 'the Doughnut'.

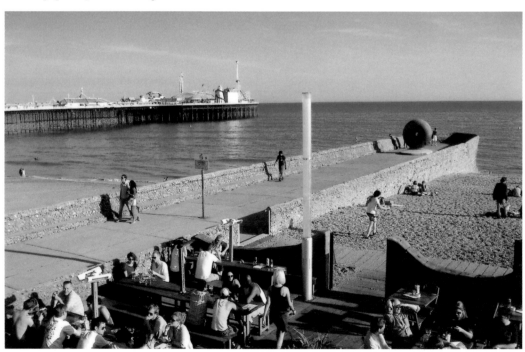

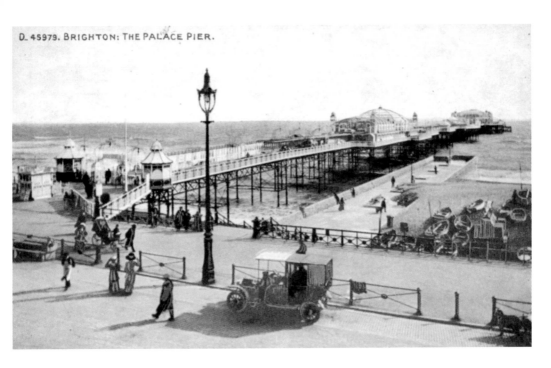

Palace Pier and Seafront

Although the postcard depicts a familiar viewpoint, it had to be included in this book both because it is in colour and for the wonderful early motor car parked in solitary splendour. The recent view was taken during a warm spell of weather in April 2011, when two stilt-walking musicians called the Top Bananas were making people smile and get out their cameras. In the distance, the Brighton Pier sign can be seen between them.

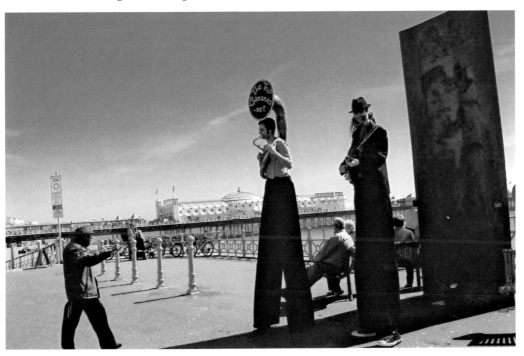

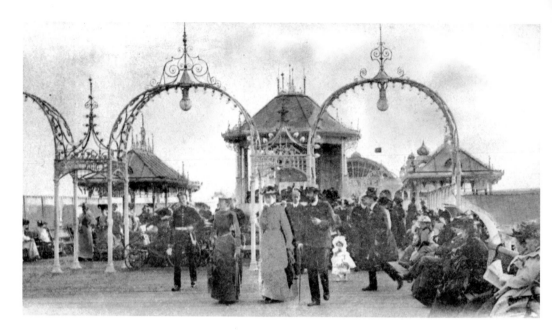

On the Palace Pier

The pier is very crowded in this scene. The clue might lie in the military looking gentleman next to a lady in a red blouse. Perhaps he was one of the volunteers and when they camped at Brighton there was an influx of visitors. The second view was taken on a warm evening in June 2010 and captures a seagull in mid-flight.

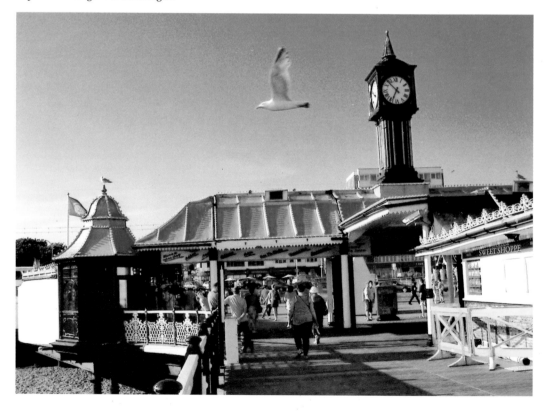

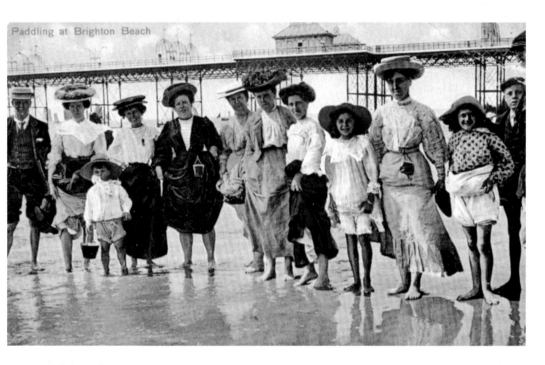

Paddling at Brighton Beach

On the Beach

This is a marvellous postcard – full of colour and life, extraordinary hats and Edwardian costumes. The modern view was taken on 13 June 2010. The turbaned Sikhs are veteran soldiers with medals pinned to their chests. They had just attended the annual memorial service for Indian soldiers killed in the First World War, held at the Chattri on the Downs above Patcham.

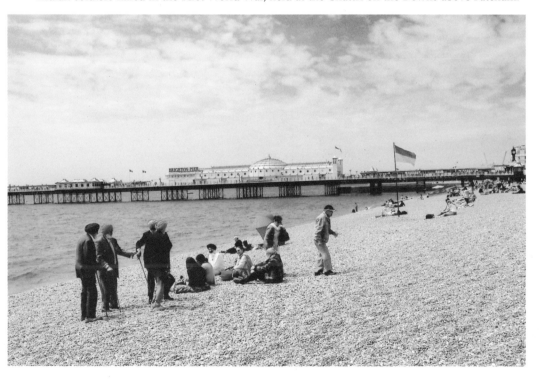

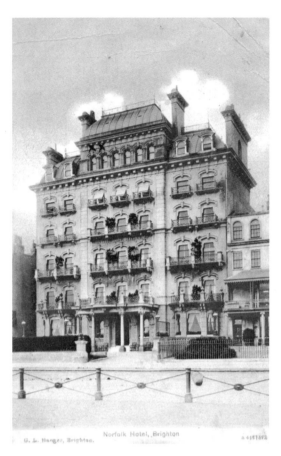

Norfolk Hotel, Brighton.

G. L. Hanger, Brighton.

A 4461893

Norfolk Hotel

It was once considered the most beautiful building in Brighton and this postcard dating from 1906 provides the evidence. The Norfolk Hotel was rebuilt in the 1860s in a charming Renaissance style designed by Horatio Goulty. It is refreshing to see how little the façade has altered over the years, apart from the loss of ironwork on the roof, but at least the original roofline has been retained.

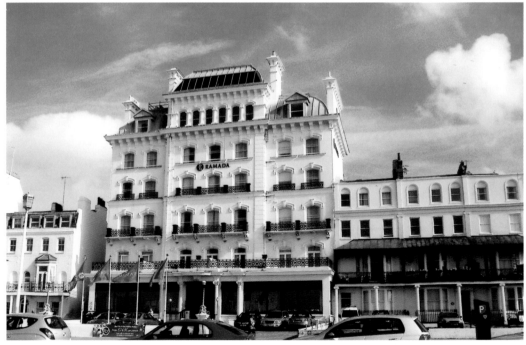

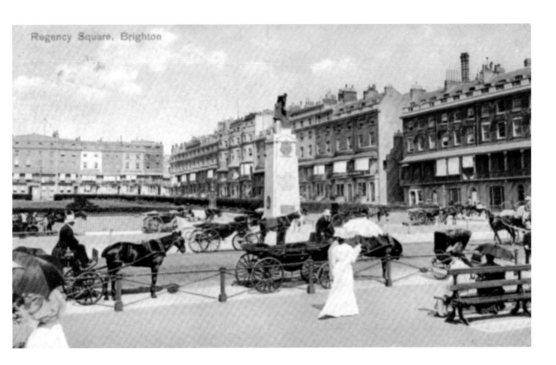

Regency Square, Brighton

Regency Square

This charming postcard is remarkable for the number of elegant horses and carriages on display. It must have appealed to a French visitor in 1908, so she sent it to her mother in Paris. The square was developed during the Regency and completed after the prince became George IV. The close-up shows houses on the east side, now all Grade II listed buildings. The typical bow windows became popular because they gave the occupants a wider view of the passing scene.

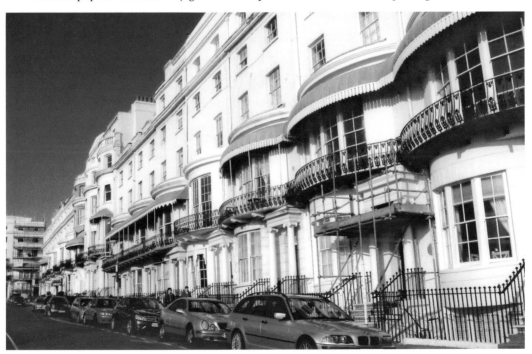

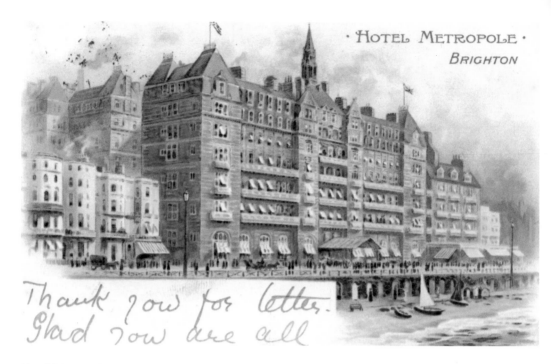

· HOTEL METROPOLE ·
BRIGHTON

*Thank you for letter.
Glad you are all*

Hotel Metropole

The pale, stuccoed buildings on the left, so typical of the area, look overwhelmed by the red-brick bulk of the Hotel Metropole, which opened in 1890. However, the slender central spire and the steeply pitched roofs at the corners lightened the effect. You can appreciate the difference these features made by glancing at the recent view with the penthouse suite there instead.

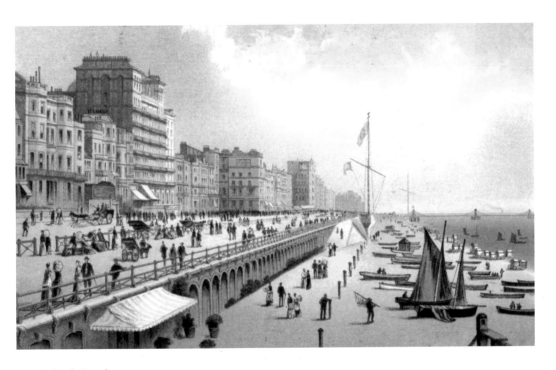

King's Road

This lovely painting shows the seafront, with the Chain Pier in the distance and fishing boats, capstans and only a few bathing machines in the foreground. The Grand Hotel dominates the promenade, with the houses on the left later to be demolished for extensions and the Metropole. However, the modern part of the Grand blends in fairly well with the original structure.

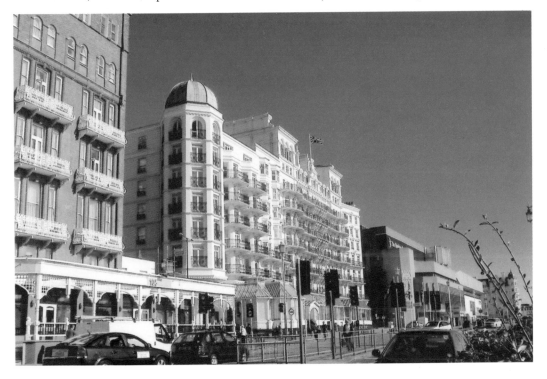

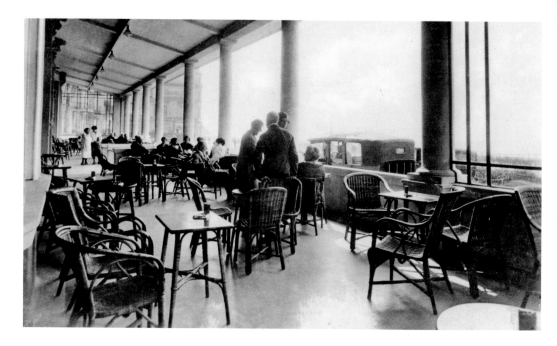

Grand Hotel

The sun lounge overlooking the seafront was opened in the early 1930s. It almost has the air of a colonial veranda. In the 1980s, there was a major refurbishment following the bomb outrage on 12 October 1984 in which five people died. Part of the front also collapsed and the rebuilding programme included remodelling the old sun lounge into a conservatory with an attractive canopied entrance.

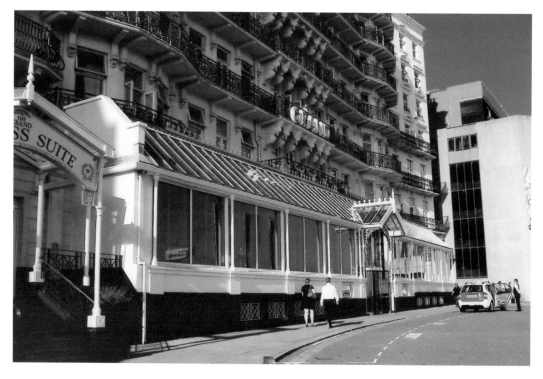

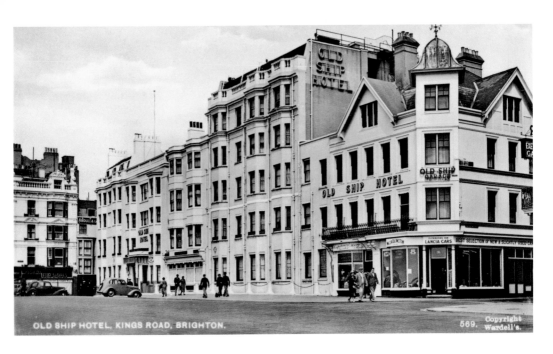

Old Ship Hotel

This was how the Old Ship looked in 1939 and, unlike other Brighton hotels, it was not commandeered by the authorities during the war. There is a quaint tower at an angle on the right; underneath a notice advertises the Old Ship Garage. The legacy of those days is that the hotel continues to have integral parking spaces, a great rarity in Brighton. Unfortunately, the corner buildings were demolished and the modern block was constructed in 1963–1964.

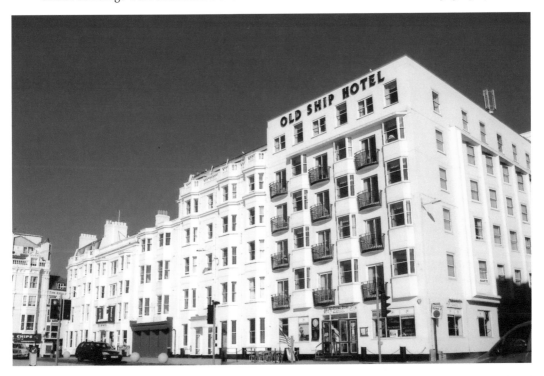

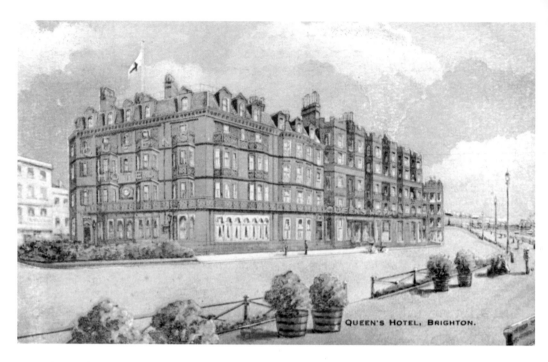

QUEEN'S HOTEL, BRIGHTON.

Queen's Hotel

While old postcards of the Metropole and Grand are plentiful, views of the Queen's Hotel are comparatively rare. It is interesting to speculate whether the façade really was that fierce ochre or whether the artist took a little licence. At any rate, today's shade of paint is more subdued. It is a major operation when the upstairs windows need cleaning and it takes a man elevated on a cherry picker well over a week to work his way around.

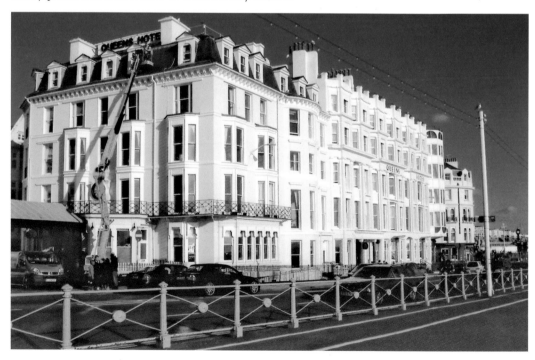

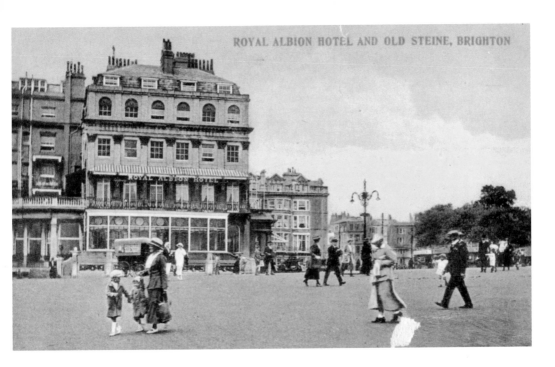

Royal Albion Hotel

The reaction of most people on seeing this postcard is to comment on the dearth of traffic, as today it would certainly not be wise to take a leisurely stroll here. Note the striped awning in the old view, as it diminishes the height of the building. In the recent photograph there is no awning and the hotel seems taller. The façade remains much the same but the forest of chimney pots has gone.

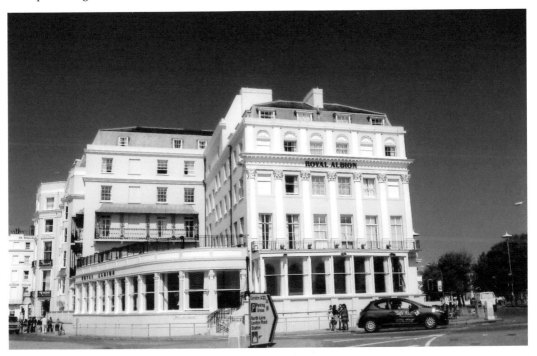

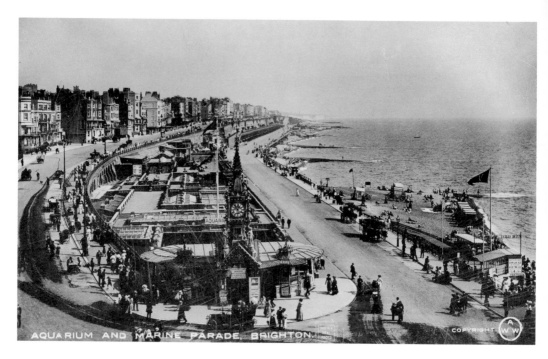

AQUARIUM AND MARINE PARADE, BRIGHTON

View from the Royal Albion Hotel

Both photographs were taken from the top floor of the hotel. Leaving aside the tall new buildings, perhaps the main difference is that the beach is larger today due to the action of the sea and the accumulation of shingle. In the distance, distinctive chalk cliffs can be glimpsed while in the foreground the old Aquarium entrance and clock tower were removed in the 1920s.

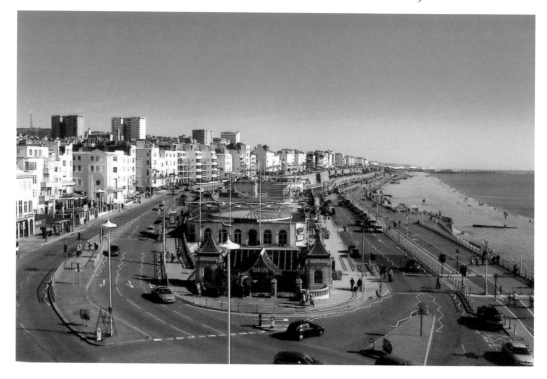

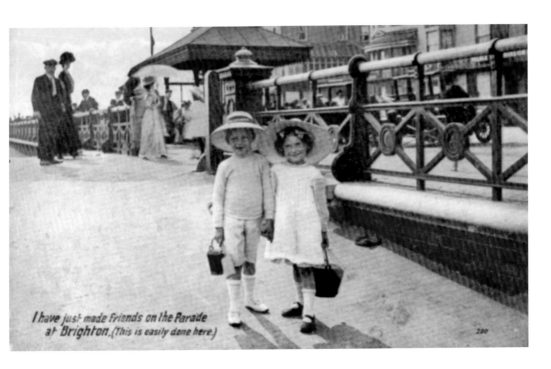

I have just made friends on the Parade at Brighton. (This is easily done here.)

On the Promenade

Cute children were often a feature of Edwardian postcards and the little boy's hatband reads HMS *Seahorse*. In this case, the card also gives us a close-up of the iron railings (erected in 1880) and shelter (constructed in around 1883). Such structures endure a terrific battering from the weather and the salt-laden air that makes the problem of maintenance something akin to painting the Forth Bridge.

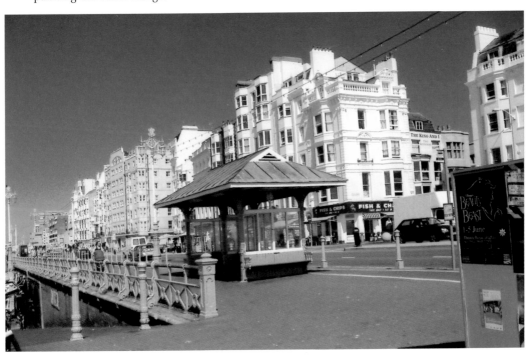

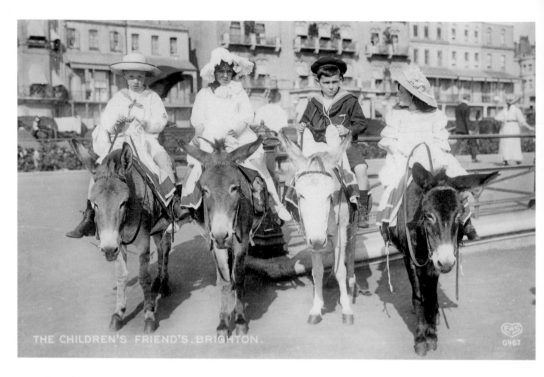

THE CHILDREN'S FRIEND'S, BRIGHTON.

Amusing the Children

It is a long time since children rode donkeys on the seafront. The expedition pictured here may have been a treat but the children seem unconvinced, and the little boy in the dark sailor suit seems especially glum. There are children present in the second photograph but it is too dark to see them. It was taken on 21 December 2010 at the 'Burning of the Clocks' celebration – an annual event culminating in a firework display over the sea.

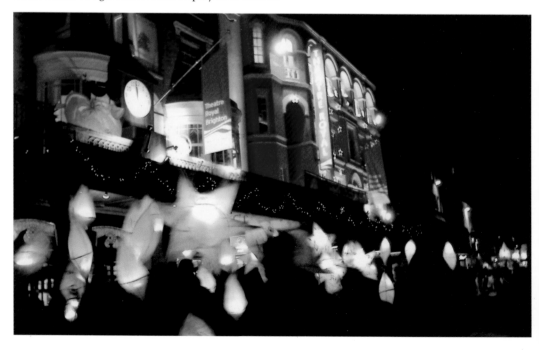

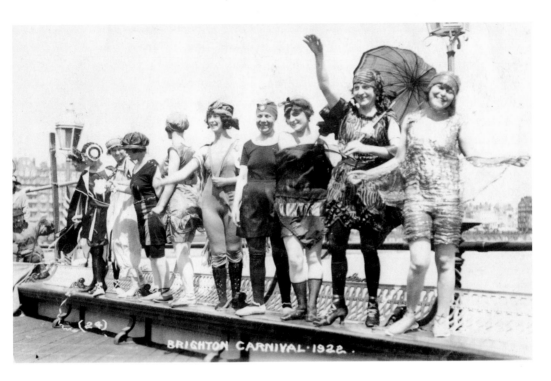

Carnival and Festival

The old postcard features bathing belles posing on the West Pier and reveals the carefree atmosphere of Brighton Carnival in 1922. The second view was taken on 1 May 2010 and features some of the many participants of the Children's Parade, all wearing colourful costumes – teachers too sometimes. The parade marks the opening of the annual Brighton Festival.

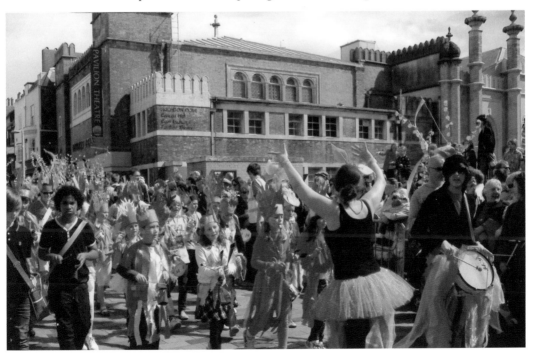

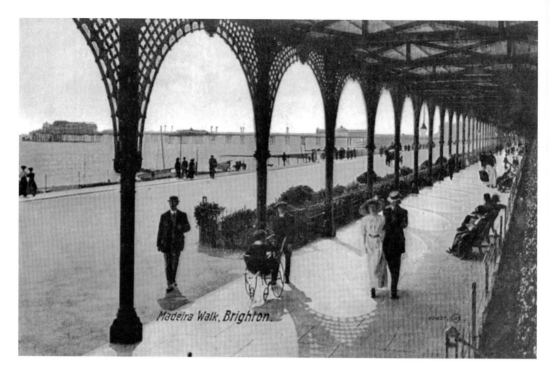

Madeira Walk

This evocative scene conjures up an Edwardian summer, when the lady in the pink dress obviously felt it was too hot to promenade in the sunshine. The delicate lattice-like ironwork is a delight. The recent photograph was taken on 13 June 2010 when a bus rally was held at Madeira Drive to celebrate Brighton & Hove Bus Company's 75 years of operation.

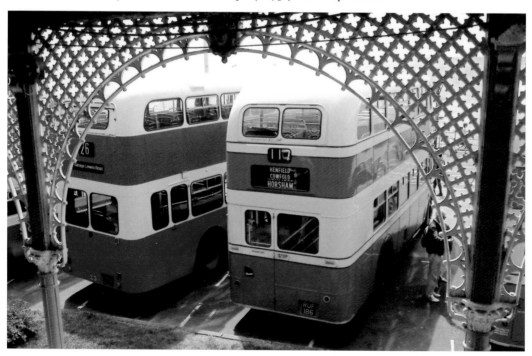

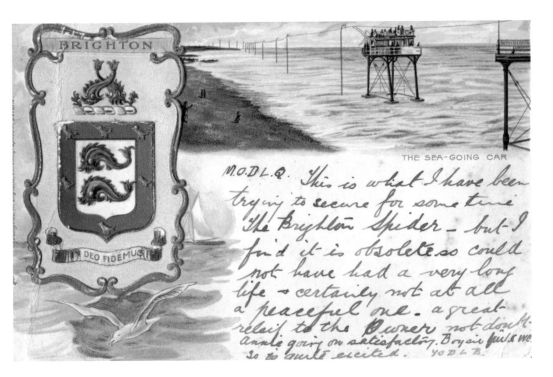

THE SEA-GOING CAR

M.O.D.L.Q. This is what I have been trying to secure for some time. The Brighton Spider — but I find it is obsolete so could not have had a very long life — certainly not at all a peaceful one. a great relief to the owners not doubt. Annie going on satisfactory. Boys is puts me. So is quite excited. YoD&B.

Modes of Transport

The visitor who wrote this postcard was too late to experience the sea-going car, as it was only in operation from 1896 to 1900. He called it 'the Brighton Spider'; locals dubbed it Daddy-Longlegs, but its official name was *Pioneer*. The second photograph shows admiring crowds at the bus rally on 13 June 2010. It was stated that Brighton & Hove Bus Company operate 233 double-deckers, but the total (including single-deckers and coaches) is 295 vehicles.

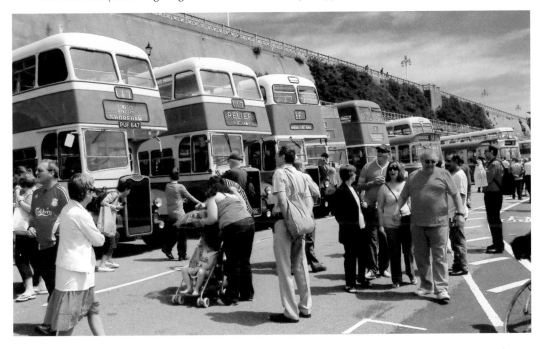

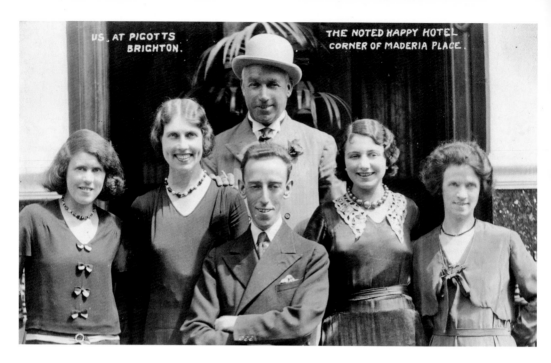

Madeira Place

This evocative portrait from the 1920s is of the staff at Pigott's on the corner of Madeira Place. In 1925, the proprietor was Mr F. O. Pigott, but it was actually called St James's Hotel. In 1885, the hotel boasted the first bar in Brighton to be lit by electricity and, consequently, the atmosphere was light and refreshing in hot weather. The street dates back to the late eighteenth century and was called originally Jermyn (or German) Place.

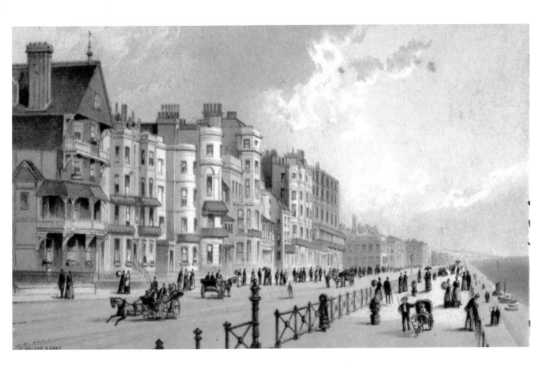

Marine Parade

The postcard is another lovely old painting, this time of Marine Parade. Note the quirky mixture of architectural styles. The red-brick house with the imposing chimney-stack occupies the corner site of Charlotte Street and is known today as the Lanes Hotel. Nöel Coward once stayed there and whilst in residence wrote *Glamorous Nights*.

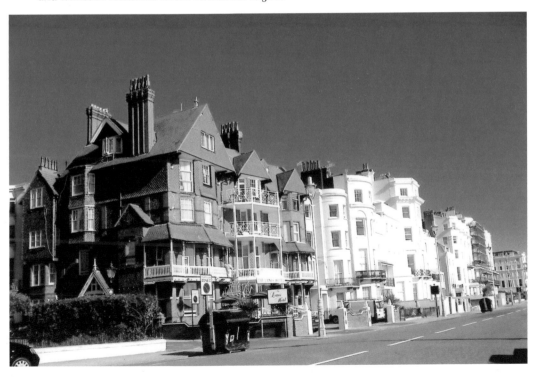

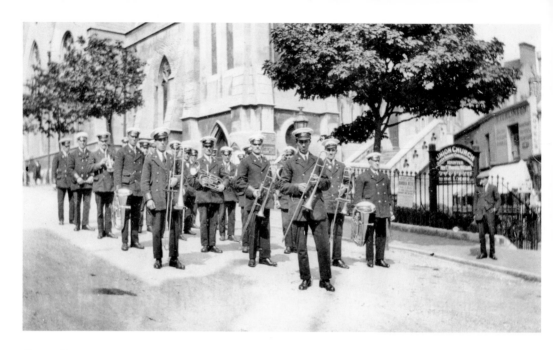

Queen Square

Behind this splendid group of bandsmen stands Union Church whose minister from 1909 to 1931 was the Revd T. Rhondda Williams – you can see his name on the notice board. Perhaps he was of a romantic turn of mind; at any rate his house in Hove Park Road was called Avalon. The church closed in 1983 and in 1985 work started on Queen Square House, seen in the recent photograph.

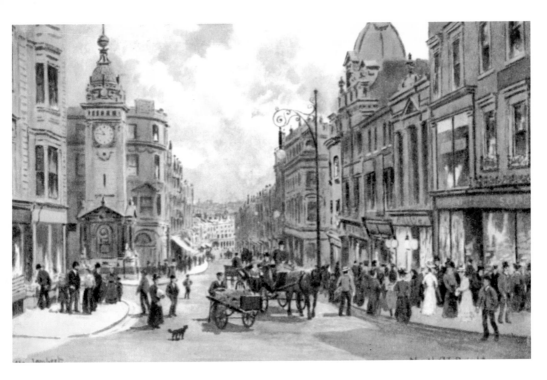

North Street and the Clock Tower

Clem Lambert painted this attractive scene and it is one of a series produced by the *Sussex Daily News*, entitled 'Clem Lambert's Brighton'. Clem was a prolific local artist whose sister presented some eighty of his works to Hove Museum. Clem's large oil painting of the Chattri was taken as a gift to India when the Prince of Wales embarked on a grand tour aboard HMS *Renown* in 1921. Festoons of Christmas lights glitter in the second view.

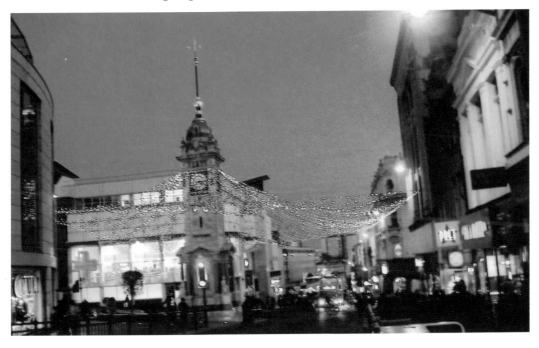

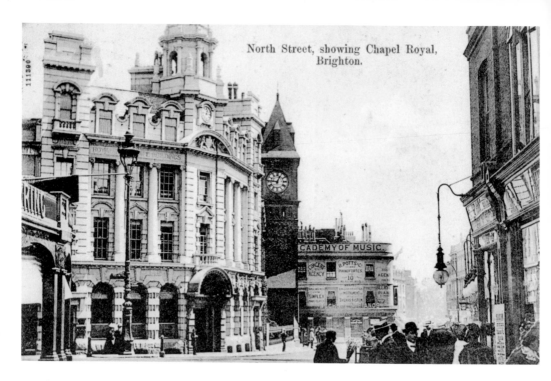

North Street, showing Chapel Royal,
Brighton.

North Street

The magnificent pile of the Royal Insurance Buildings dominates the view. The architects Clayton & Black designed them in 1904, and this photograph was taken five years later. In the distance, the Academy of Music juts out into the thoroughfare. If you needed a Bechstein piano, this was the place to go. The Academy was demolished in 1930 and the building line set back. Prince's House was erected on the site and can be seen in the recent photograph.

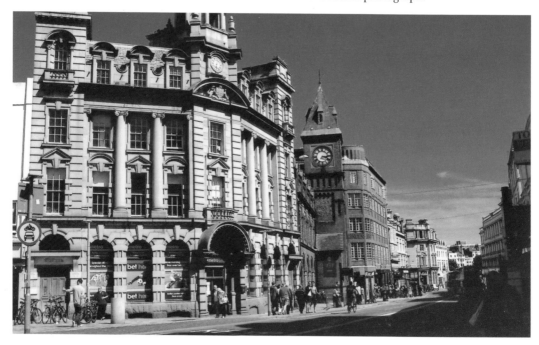

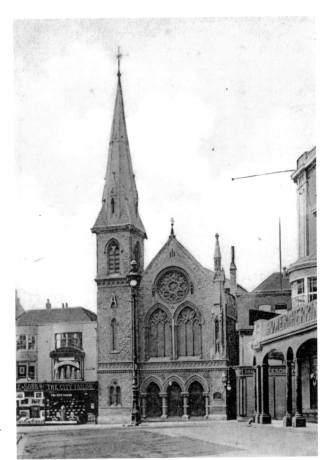

North Street and the Lost Church

The Countess of Huntingdon's original chapel was founded here in 1761, but was completely rebuilt in the 1870s and lasted just over 100 years. The photographer made a fine job of capturing this elegant building because as it is north facing, it is difficult to capture the right light. The modern edifice built on the site is called Huntingdon House.

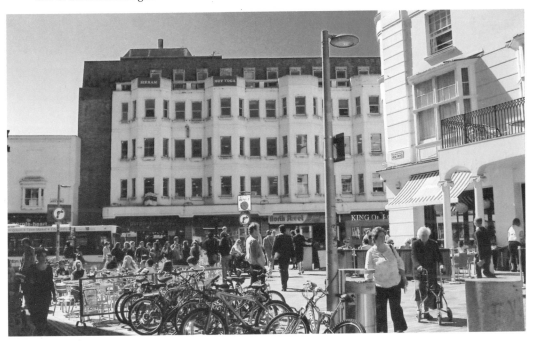

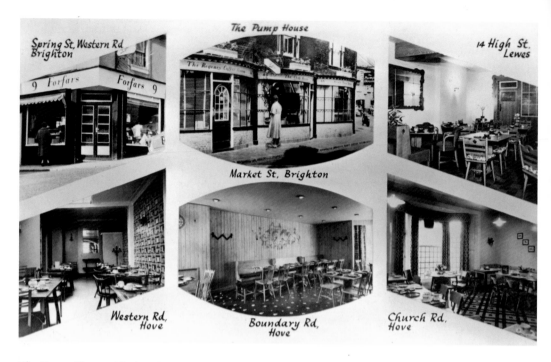

Spring St, Western Rd, Brighton

9 Forfars Forfars 9

The Pump House

The Regency Coffee Room

14 High St. Lewes

Market St, Brighton

Western Rd, Hove

Boundary Rd, Hove

Church Rd, Hove

The Pump House, Market Street

The Forfar family once owned the Pump House and other properties shown in this promotional postcard, having started off with a bakery in Hove in the 1880s. In 1936 the Cutress family took over the business. The Pump House was named after the adjacent town well and its black mathematical tiles are unusual in Brighton. The tiles and bow windows date from the early nineteenth century, but the building itself goes back at least to the 1770s.

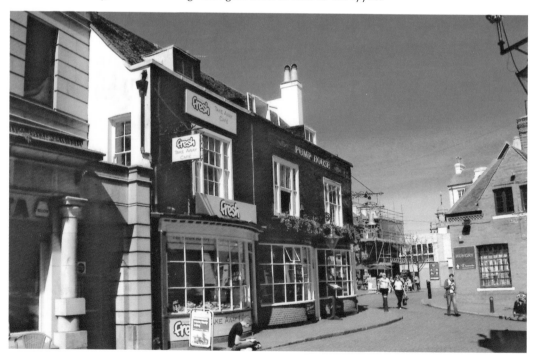

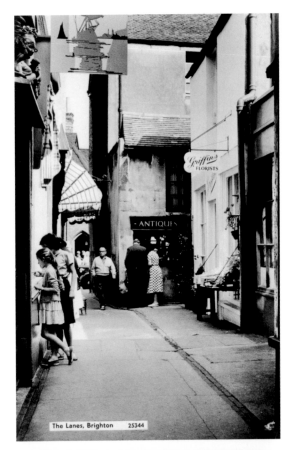

The Lanes

It is a marvel that the Lanes have survived. Although today they are valued and much visited, they were once considered down-at-heel and ripe for redevelopment. The first view is of Meeting House Lane and the second depicts Brighton Square, built in 1966 as an addition to the Lanes. James Osborne created the Dolphin Fountain, seen in all its Christmas splendour. He was a local, self-taught artist who wanted to be a sculptor from the age of eight.

The Lanes, Brighton 25344

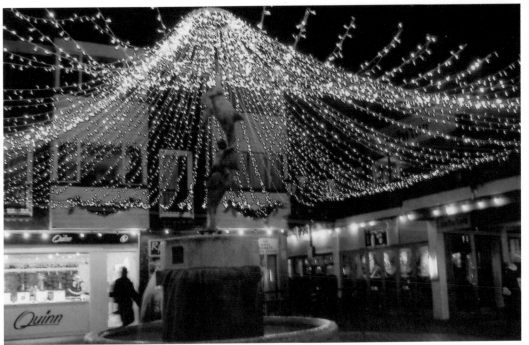

43

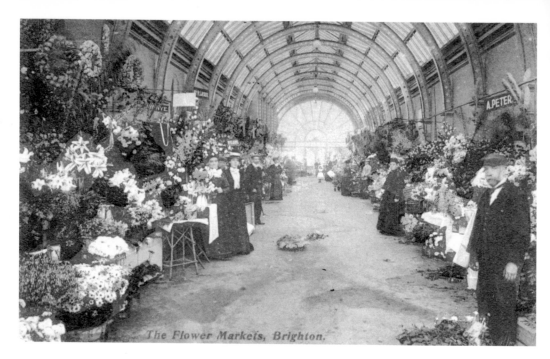

The Flower Markets, Brighton.

Floral Hall

The Floral Hall was part of the market building designed by Francis May, the borough engineer, and erected in 1900/01. As can be seen from the postcard, it was an airy structure with light flooding through the glass panels in the arched roof. A new market building was erected in 1938 in Circus Street and this one closed. For many years, the site was used as a car park and was later redeveloped as Bartholomew Square.

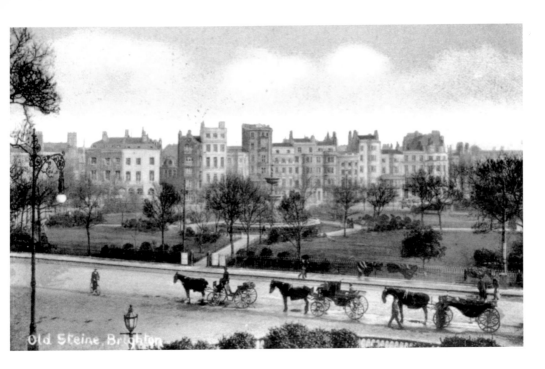

Old Steine

The charm of this 1910 view across the Old Steine lies in the diversity of buildings with their different heights and styles of architecture. Many of them remain today. But it is a pity we have to put up with a utilitarian lamppost rather than the elegant cast-iron standard to be seen on the left of the postcard.

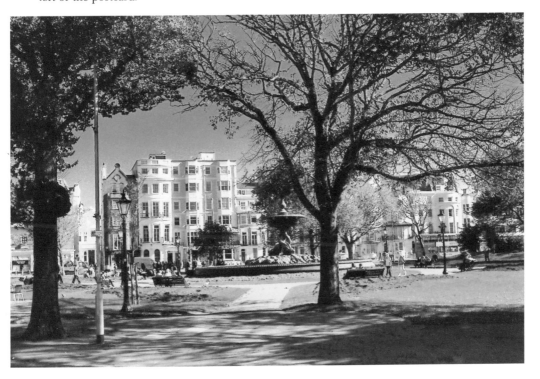

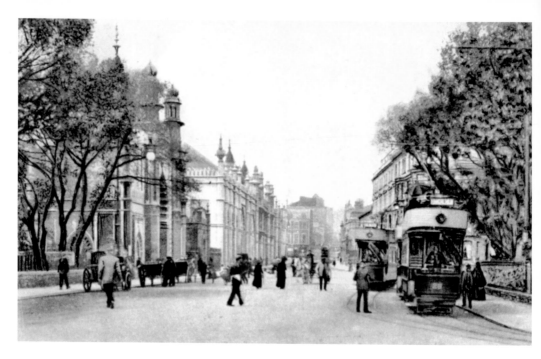

Looking Towards Church Street

The front tram is headed for Ditchling Road and a female passenger on the top deck has raised her umbrella. The trams were electrically operated but the Big Lemon bus, seen in the second view, runs on bio-diesel made from locally sourced recycled cooking oil. Tom Druitt founded the firm in 2007 and by March 2011 there were ten yellow buses operating on three separate routes.

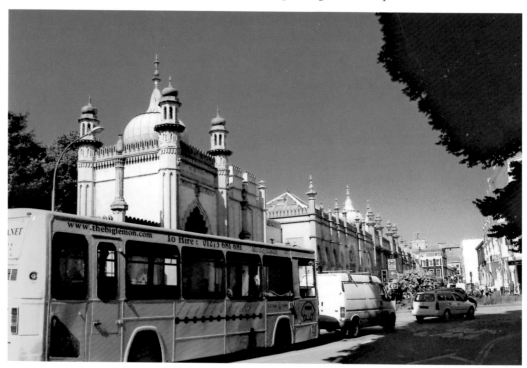

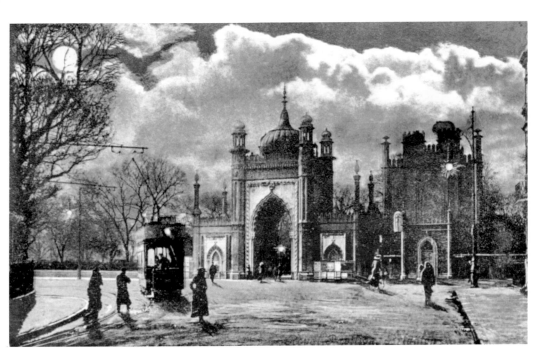

By the North Gate

This postcard has been hand-coloured to provide a nostalgic glimpse of a lighted tram under a full moon, trundling past the North Gate of the Royal Pavilion. The main difference between the two views is that the direction of traffic has changed completely and the modern vehicles are heading north.

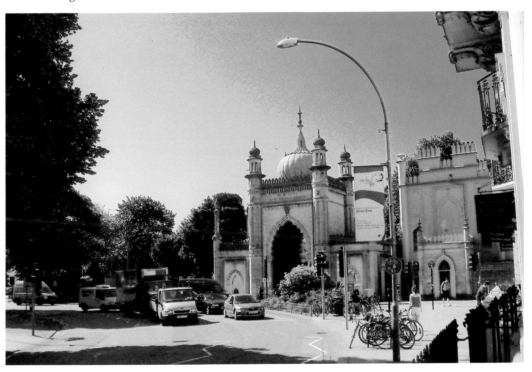

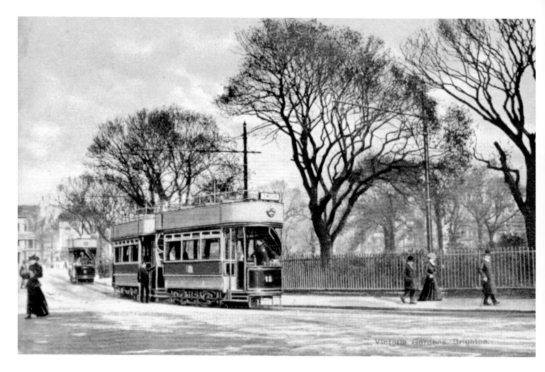

Victoria Gardens

The tram at the front has Lewes Road on its destination board. Perhaps it was a chilly day, because the lady on the left appears to have hidden her hands in a large muff. In the distance, some old buildings can be seen at the corner of Gloucester Place, which were demolished in the 1930s. The present structure at 1–9 Gloucester Place is known as Sussex House, erected in 1985 and belongs to Lloyds TSB.

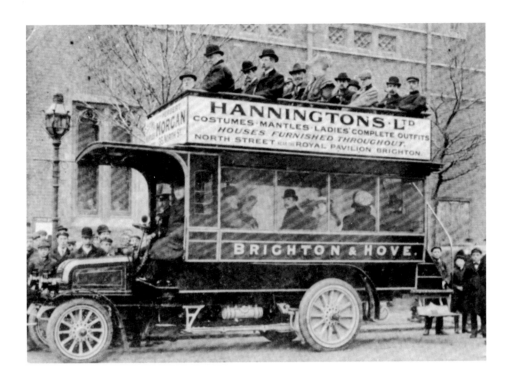

Motor Buses

The first motor bus in the area was a Milnes–Daimler vehicle and it created enormous interest. It arrived in December 1903 and this card was posted in February 1905 when it was still something of a novelty. Alice wrote on the card to a child called Stanley 'this is a photo of one of our motor buses, it is lovely to ride on them'. Bus enthusiasts are frequently seen in Churchill Square, where many buses pull up.

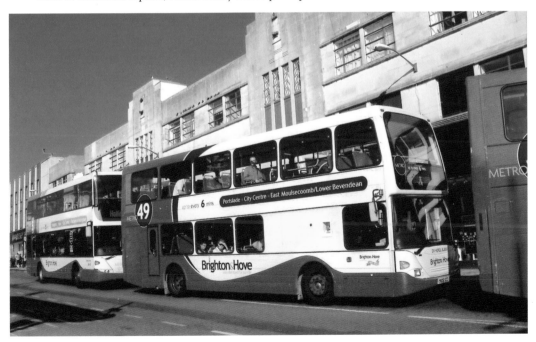

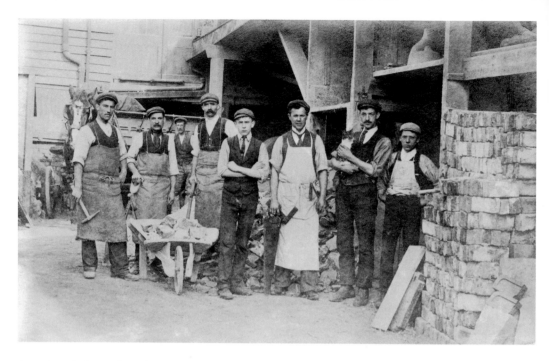

Saunders & Son, Edward Street

Saunders & Son, a building firm, was established at 165–167 Edward Street in 1889. This photograph dates from around 1910. In the 1916 Directory, the following neighbours were listed: W. H. Hughes, saddler, at number 168, C. Goll, hairdresser, at number 169 and Mrs Pettitt, confectioner, at number 170. Saunders continued until around 1950. The second view shows modern buildings on the corner of Dorset Street and Edward Street.

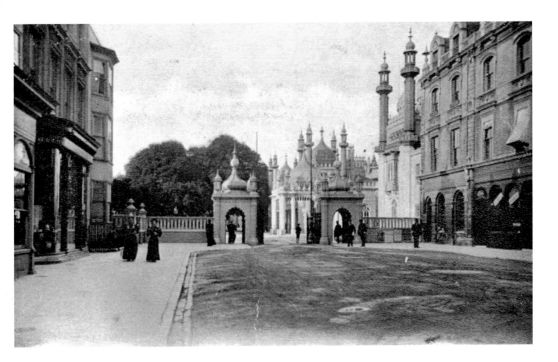

Pavilion Buildings

The street looks strangely deserted but the eye is drawn at once to the numerous domes and minarets. There were more of them then than there are today because the two charming little gateways were replaced by the more sombre single gateway unveiled in 1921. Today, the area is usually thronged by people in a pedestrian-only space and chairs and tables are set outside the restaurants.

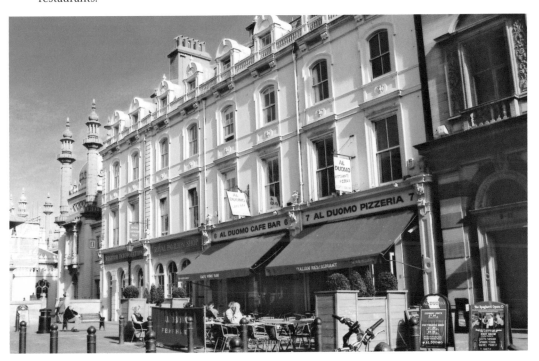

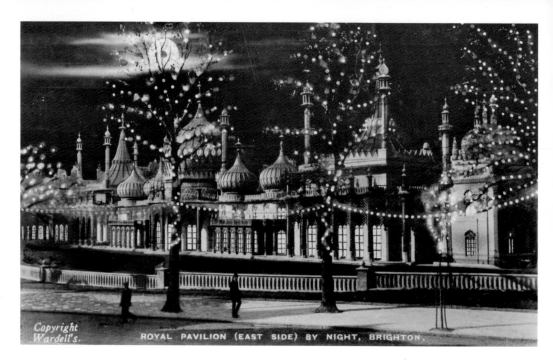

Copyright
Wardell's. ROYAL PAVILION (EAST SIDE) BY NIGHT, BRIGHTON.

Royal Pavilion

Similar to the two postcards of the seafront at the beginning of this book, this one also owes something to the hand-colourist. But it does convey a more flamboyant attitude towards the Royal Pavilion in times past. For instance, the structure was once flood-lit with a changing sequence of colours but this would probably not be considered good taste today. Besides, nothing can be as stunning as the outline of the palace against a deep blue sky.

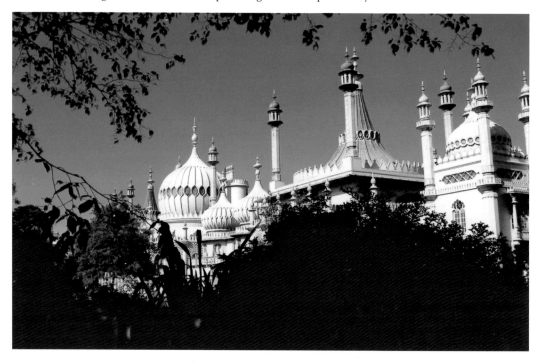

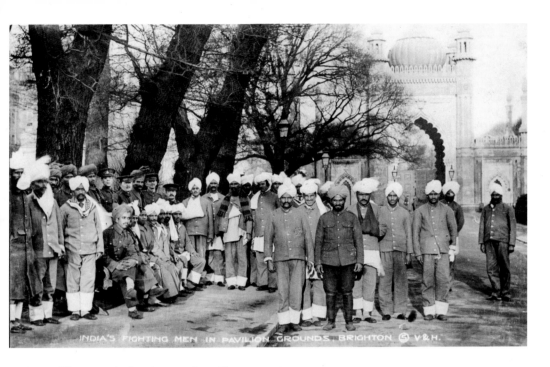

INDIA'S FIGHTING MEN IN PAVILION GROUNDS, BRIGHTON © V&H.

A Different Role for the Royal Pavilion

Local people were very interested in the Indian soldiers who were nursed back to health in the Royal Pavilion and the Dome. During the First World War, several military hospitals were established in Brighton but many more photographs were taken of the Indian patients than their British counterparts. Today, the area where the turbaned figures once stood is now frequently occupied by students and visitors waiting to tour the interior of the Royal Pavilion.

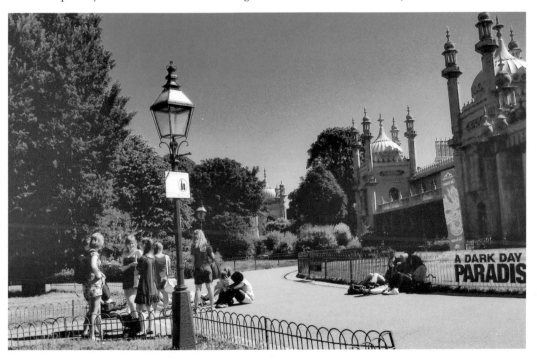

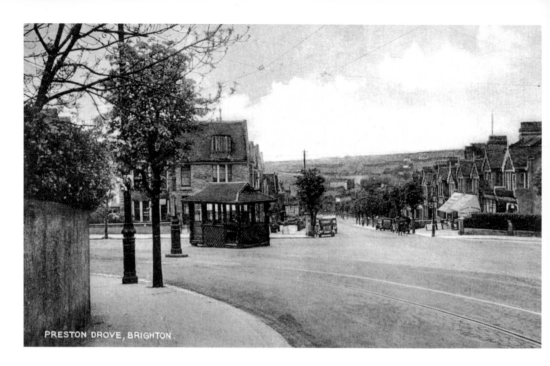

PRESTON DROVE, BRIGHTON

Preston Drove

The tram shelter stood near the junction of Beaconsfield Villas and Preston Drove. In 1915, there were some sixteen of these rustic-style shelters dotted around the tramway system. In August 2010, it was stated that the Ditchling Road shelter had been restored at a cost of £10,000. Meanwhile, two other shelters have gone to Amberley Museum and another is to be found at Stanmer Rural Museum.

54

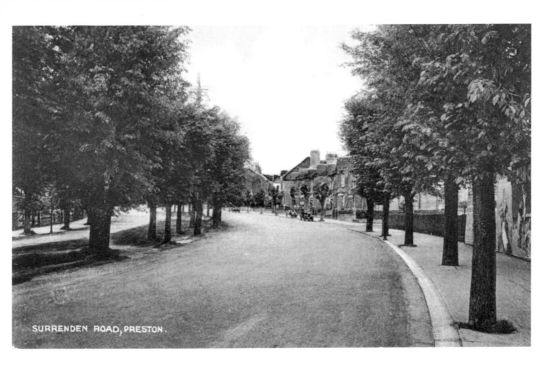

Surrenden Road

It seems probable that this view was taken at around the same time as the previous postcard. Surrenden Road is unusual in a place like Brighton with its many narrow streets, because it is a wide thoroughfare with a fine stand of trees in the central reservation. The road was laid out in the 1870s, not for the benefit of wheeled vehicles, but to provide a pleasant horseback ride from Preston Park to Ditchling Road.

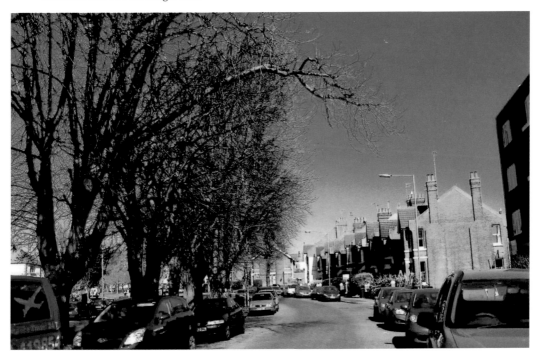

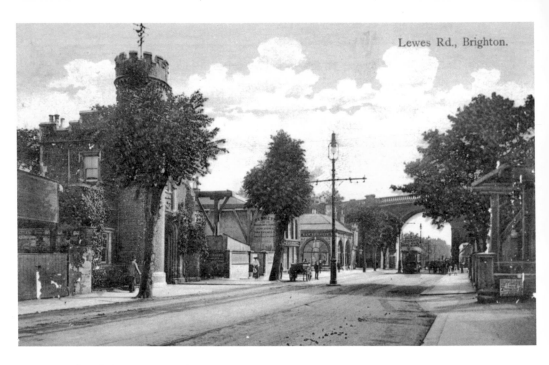

Lewes Rd., Brighton.

Lewes Road and the Extra-Mural Cemetery

It is a shame that the imposing gateway and castellated tower have not been preserved, as they add a certain distinction to the urban scene. The tower marked the entrance to the Extra-Mural Cemetery, but was destroyed in 1961. The Lewes Road viaduct was demolished in two stages in 1976 and 1983. The recent photograph depicts some of the ornate memorials to be seen in the cemetery.

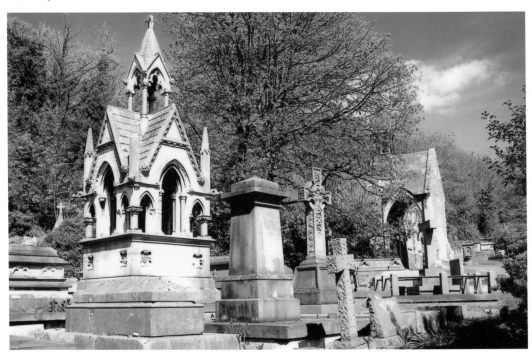

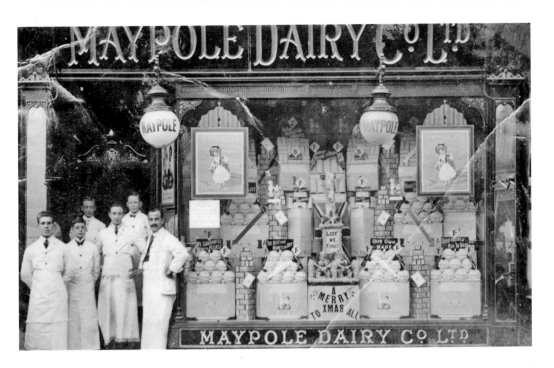

Lewes Road and Maypole Dairy

The Maypole Dairy was situated at 71 Lewes Road. The photograph dates from the 1920s and depicts the window decked for Christmas. But it would not be a season of joy for everyone so soon after the war, as the text in the window 'Lest we forget' reminds us. The two posters featuring a fetching young lady advertise Maypole's own brand of tea. Today, Charisma Hair Salon occupies the premises but the Maypole mosaic on the threshold remains.

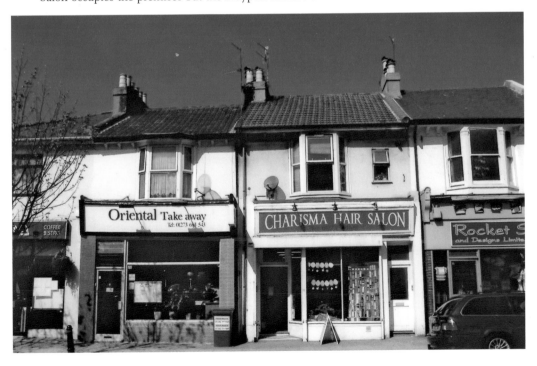

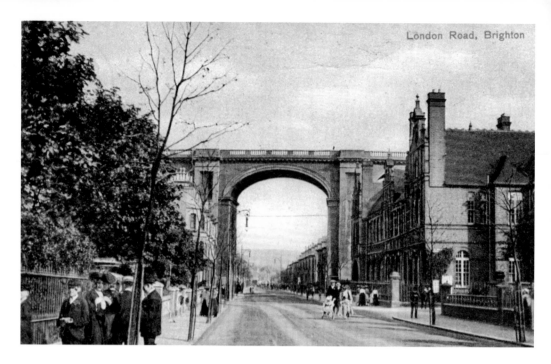

London Road Viaduct

Despite its name the structure traverses Preston Road. It is difficult to imagine that when the railway viaduct first opened in 1846, the passengers looked down upon a network of open fields, and it stayed that way until the 1870s. It is claimed that at least ten million bricks were used in the viaduct's construction. The school on the right was the Preston Road School, dating from 1880. The second view differs from the postcard in that it looks north.

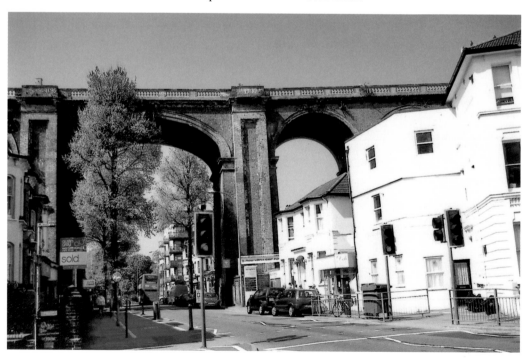

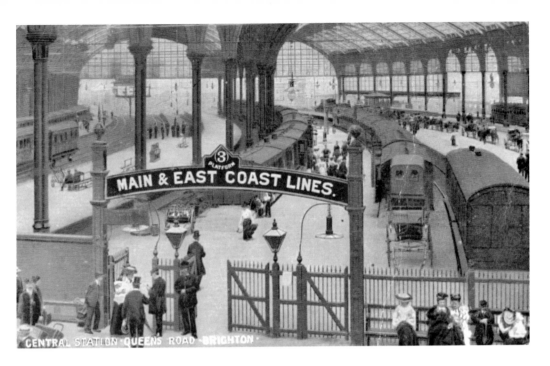

Brighton Station

This postcard provides a good view of platform three and it is fascinating to see the smartly dressed passengers – city gents in their top hats and ladies wearing their best outfits. It also gives us a glimpse of the magnificent roof of glass and iron arching over the platforms. This has been beautifully restored in recent years. The modern photograph shows some of the intricate detail of the entrance canopy.

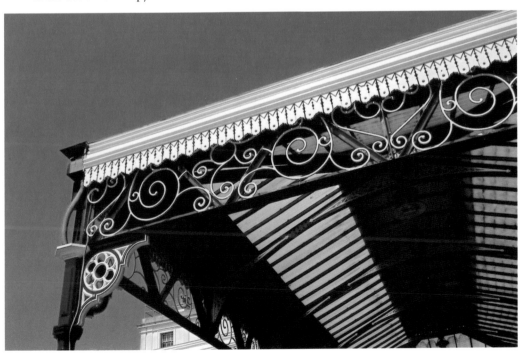

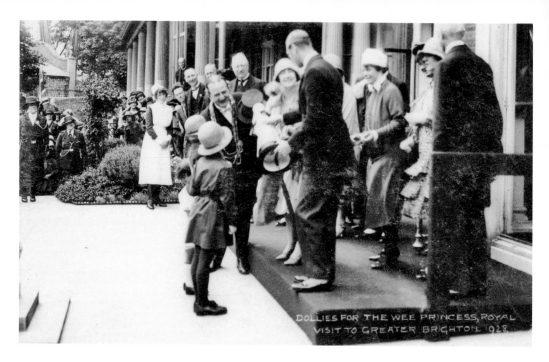

DOLLIES FOR THE WEE PRINCESS, ROYAL VISIT TO GREATER BRIGHTON 1928

Royal Alexandra Hospital for Children

Princess Alexandra opened the hospital in 1881 but the postcard shows the Duke and Duchess of York at the opening of the east wing on 30 May 1928. They were presented with two dolls for two-year-old Princess Elizabeth (our present Queen), one of them dressed as a nurse. In 2007, a new children's hospital opened and it seemed likely the old one would be demolished, but now there is hope that part of the building could be preserved.

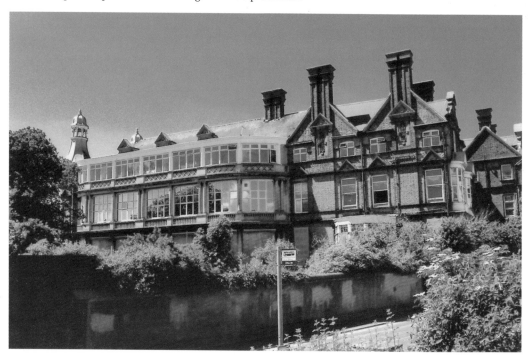

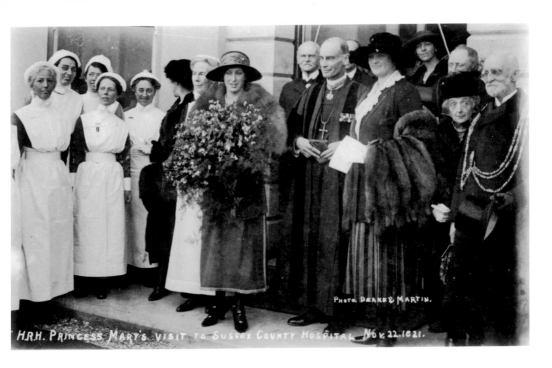

HRH. PRINCESS MARY'S VISIT TO SUSSEX COUNTY HOSPITAL. Nov. 22. 1921.

Photo. DEANE & MARTIN.

Royal Sussex County Hospital

Princess Mary was the only daughter of George V but she had five brothers. Shortly before her engagement to Viscount Lascelles was announced, in November 1921, she visited Brighton. During the course of a busy day she opened the new nurses' home at the Royal Sussex County Hospital. She wore a grey fox fur around her shoulders while her muff was made of skunk fur. The recent photograph shows the frontage of the hospital in October 2010.

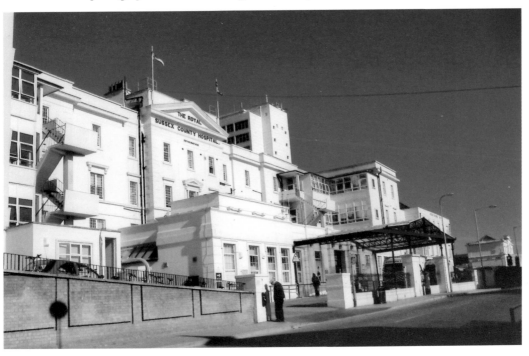

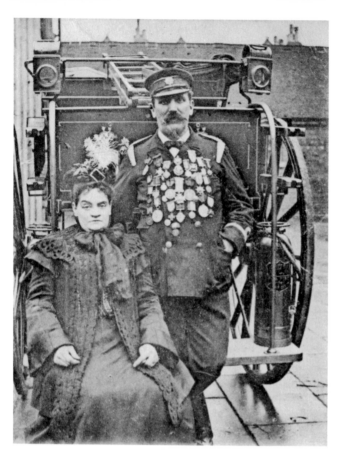

Fire Chiefs

Louis Victor Lacroix was superintendent of Brighton Fire Brigade from 1888 to 1921. The photograph of Mr and Mrs Lacroix was taken in 1904 at Preston Circus Fire Station – established three years earlier. It would be interesting to know if he acquired any more medals. The second photograph was taken at the Fire Station Open Day on 21 August 2010 with Tony Gurr, Station Manager, greeting Geoff Wells, Mayor of Brighton and Hove.

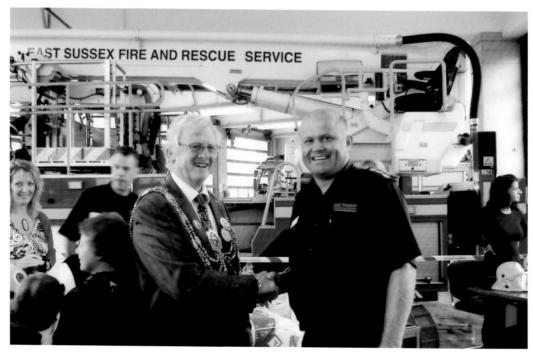

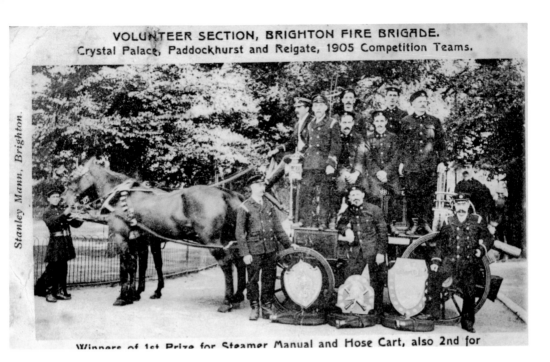

VOLUNTEER SECTION, BRIGHTON FIRE BRIGADE.
Crystal Palace, Paddockhurst and Reigate, 1905 Competition Teams.

Stanley Mann, Brighton.

Winners of 1st Prize for Steamer Manual and Hose Cart, also 2nd for

Fire Brigade Vehicles

The Volunteer Section of Brighton Fire Brigade was based at 4 Duke Street. They were obviously a keen body of men who enjoyed entering competitions and winning them. In 1905, the competition team won first prize for the steamer manual and hose cart and first prize for the six-man escape and manual rescue drill. Compare their horse-drawn equipage with a modern vehicle photographed in 2010.

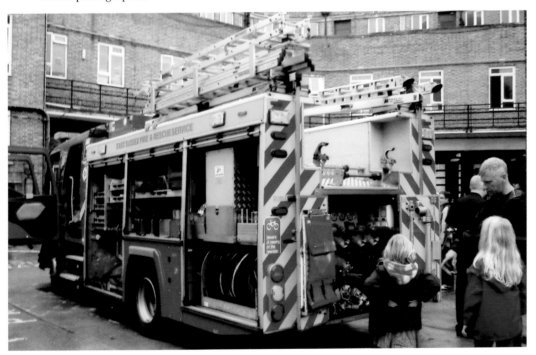

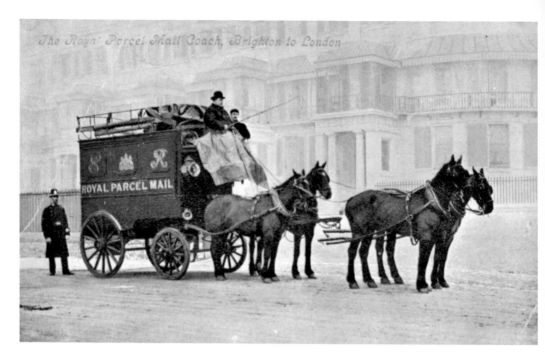

The Royal Parcel Mail Coach, Brighton to London

Royal Mail – From Horses to Trolleys

No doubt this postcard, taken in 1905, was intended as a collector's item because the days of a horse-drawn parcel mail between London and Brighton were fast drawing to a close. The modern view was taken in George Street, Hove, on 25 June 2010 and shows Chris Stott with his trolley decorated with flags for the World Cup. Trolleys are used in areas with a heavy post load.

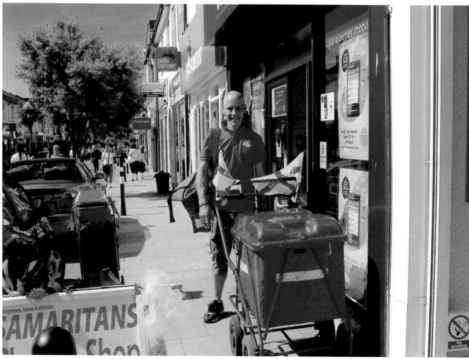

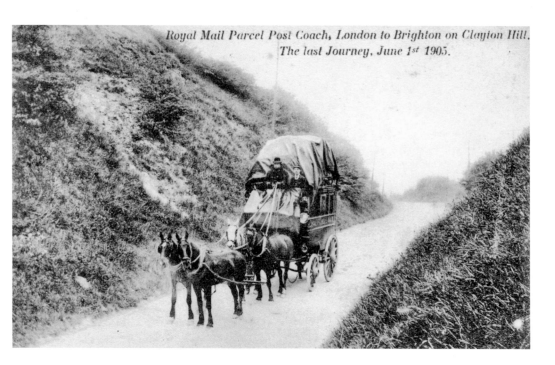

Royal Mail Parcel Post Coach, London to Brighton on Clayton Hill. The last Journey, June 1st 1905.

Royal Mail – Last Load

This photograph was taken on 1 June 1905, the last day of the Royal Mail parcel coach from London to Brighton. The poor horses must have had a struggle heaving the coach up Clayton Hill. The second photograph shows a conveyance that will also soon be history, as the Royal Mail bicycles are to be phased out. Jason Oram, based at Boundary Road, was pictured on 28 June 2010 returning from his round at Southwick Green.

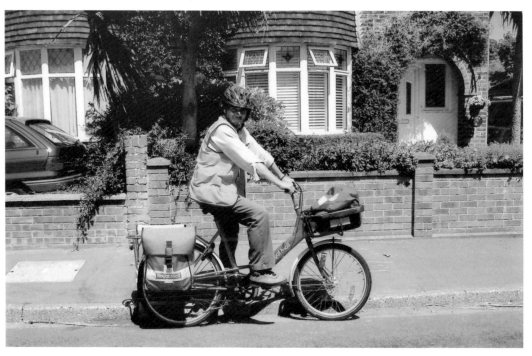

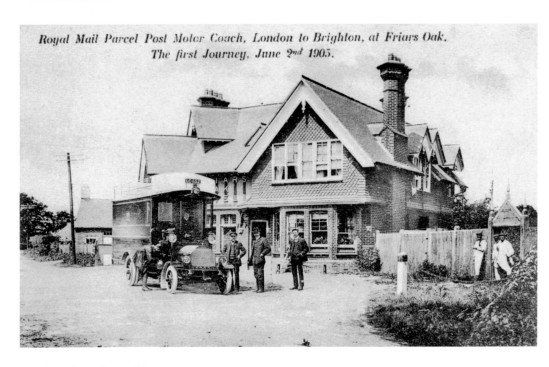

Royal Mail Parcel Post Motor Coach, London to Brighton, at Friars Oak. The first Journey, June 2nd 1905.

Royal Mail – Rain or Shine

The spanking new Parcel Post motor coach (registration number LC552) was photographed on 2 June 1905 taking a rest at Friar's Oak on its way from London to Brighton. The second photograph depicts the gallant Post Office van braving snow and ice in Portslade, the week before Christmas 2010. The apparent dent in the roof is due to a melting snowflake on the window-pane through which the photograph was taken.

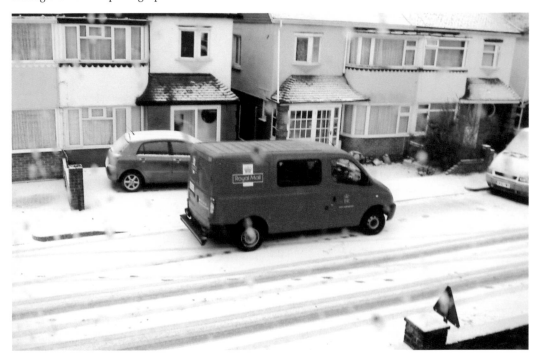

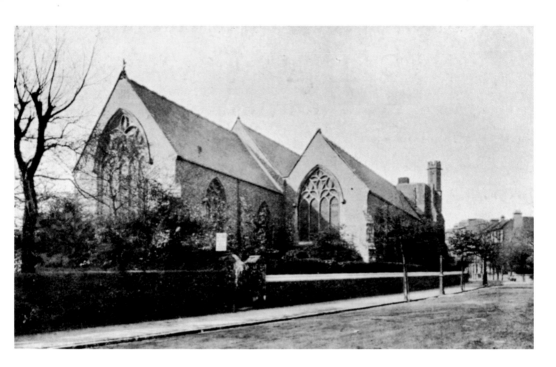

Another Lost Church

All Saints Church stood on the corner of Buckingham Place and Compton Avenue. It dated from the 1850s but was demolished in 1957. A block of flats called Buckingham Lodge was built on the site but the modest church wall survives.

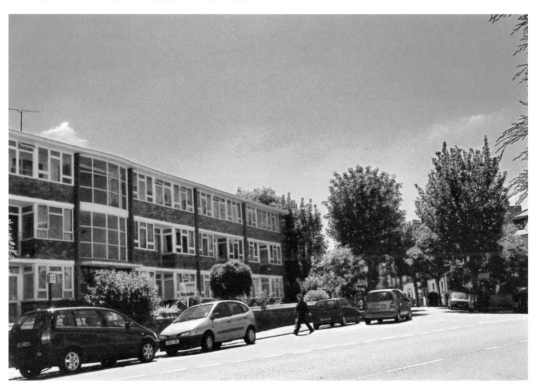

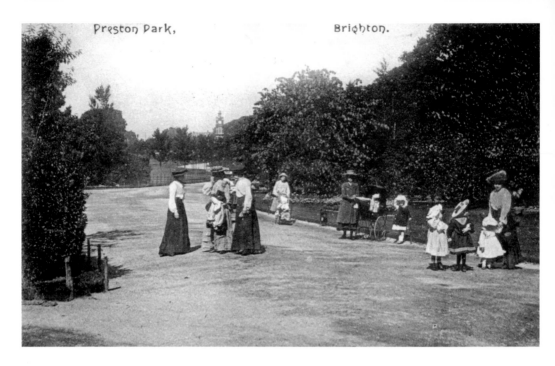

Preston Park – Clock Tower

High summer in Preston Park, 1906, and all the ladies and children have their heads well shielded from the sun. The clock tower can be seen in the background while the second view provides a closer look. Francis May, borough surveyor, designed the tower and it was inaugurated in 1892. It is an elegant structure but in the summer it is almost lost to the wider park behind its neighbouring trees.

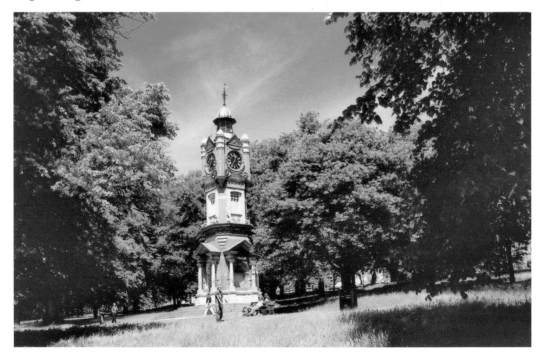

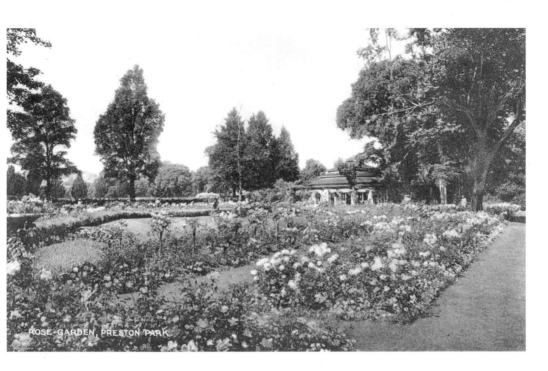

ROSE GARDEN, PRESTON PARK

Preston Park – the Rose Garden

The Rotunda Café once graced the 1924 Wembley Exhibition and Brighton Corporation purchased it five years later. The rose garden is a sight to see and the scent of the roses is unbelievable. When the second view was taken in June 2010 a party of Japanese tourists was busy photographing the many varieties of roses.

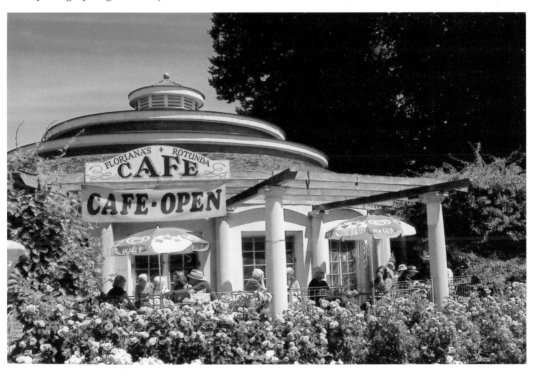

FLORIANA'S ✦ ROTUNDA
CAFE
CAFE·OPEN

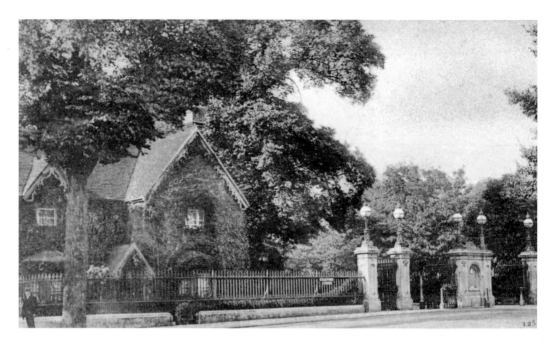

Preston Park – Old Gates and new Rockery

Another borough surveyor, Philip Lockwood, designed the cast-iron gates and gate piers in the 1880s – Lockwood was also responsible for designing the ironwork of Madeira Terrace. The park superintendent lived in the imposing lodge. In 1928, both lodge and gates were demolished. The Rockery was formally opened in 1936. Some say that the inspiration for the layout was taken from the Chinese willow pattern.

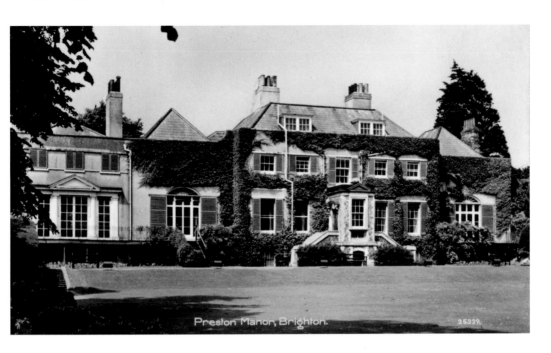

Preston Manor

Brighton acquired Preston Manor in unusual circumstances. Lady Ellen Thomas-Stanford doted on her grandson Vere and when he died in 1928 she was devastated. Her son had no time for the house, threatening to have it demolished, and so she bequeathed it to Brighton Corporation. The exterior remains much the same today although the ivy has gone. The second view is of St Peter's Church, built surprisingly close to Preston Manor.

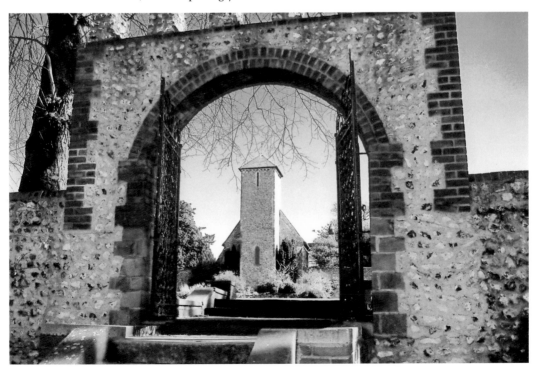

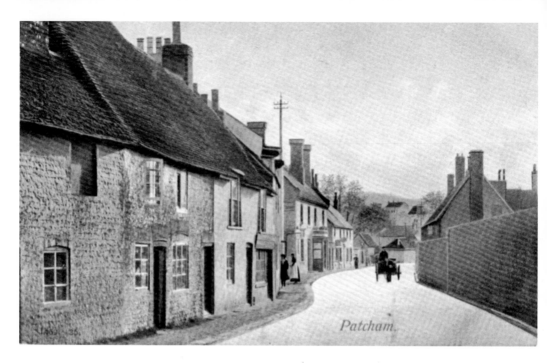

Patcham Village

It is hard to think of this quaint village street as once being part of the high road from London to Brighton. Many horse-drawn coaches must have lumbered this way with their fashionable passengers. They could partake of refreshments at the Black Lion Inn seen in the distance; the larger Black Lion Hotel did not open until 1929. The humble flint cottages now enjoy the status of listed buildings.

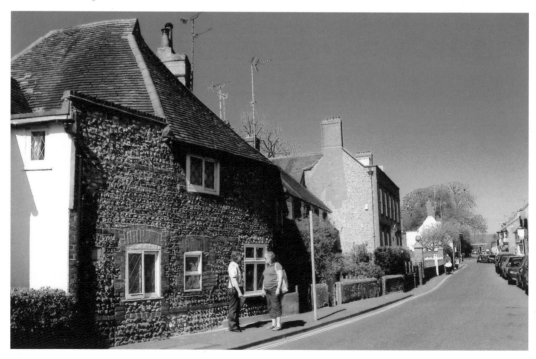

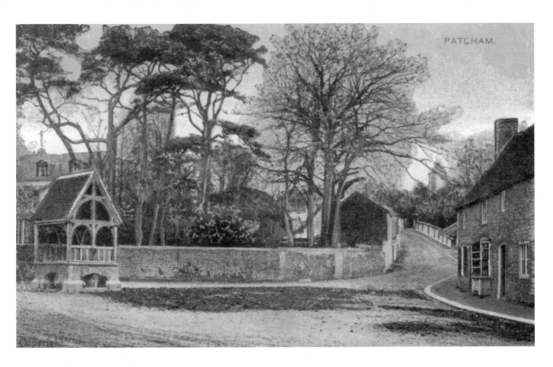

Patcham Fountain

There was once a donkey wheel on this site by which means water for the villagers was drawn up from the depths. Instead of a statue or a clock tower it was decided to erect this charming fountain to commemorate Queen Victoria's Golden Jubilee in 1887. The structure seen today is not the original one because, unhappily, it had a close encounter with a bus. Today it is difficult to photograph a wider view due to the nearby bus shelter.

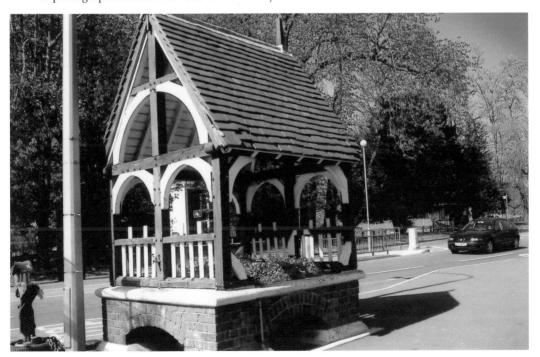

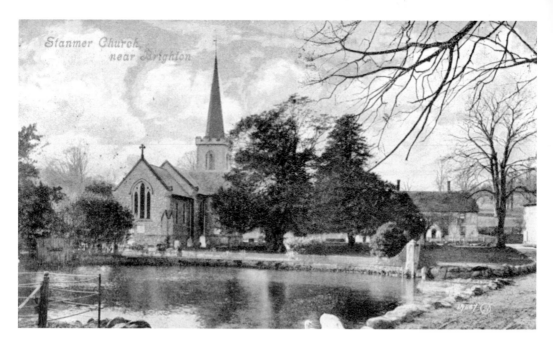

Stanmer Church

It is unusual for such a fine looking church not to have a dedication of its own. If the original church was named after a saint, the fact has not come down to us. This church was built in 1838 and became redundant in 2008. The postcard view of 1907 is a picturesque one. Unfortunately, today the pond is muddy and its surroundings too overgrown to take a photograph from a similar standpoint.

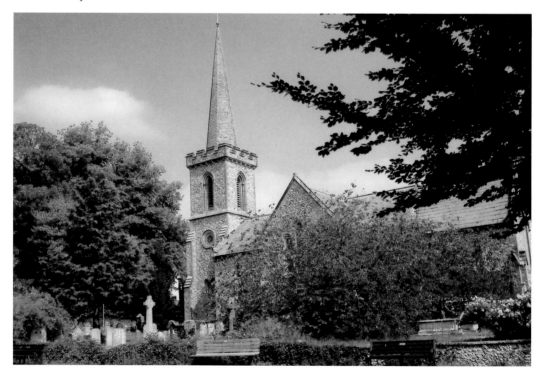

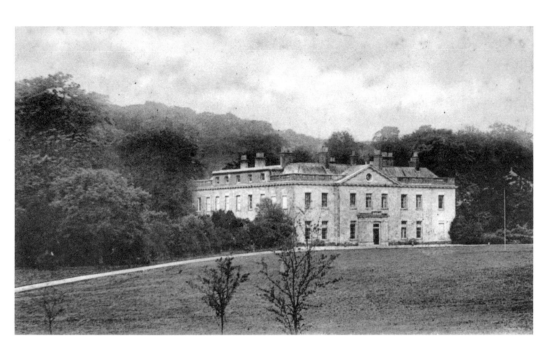

Stanmer House

When the postcard view was taken, Stanmer House still belonged to the Pelham family, the Earls of Chichester. During the Second World War, much damage was caused not by enemy action but by the occupation of Canadian troops who used the houses in the evacuated village for target practice. Since 1947, the house and park have belonged to Brighton but for many years the house was left neglected and was once home to squatters. But at last it has been restored.

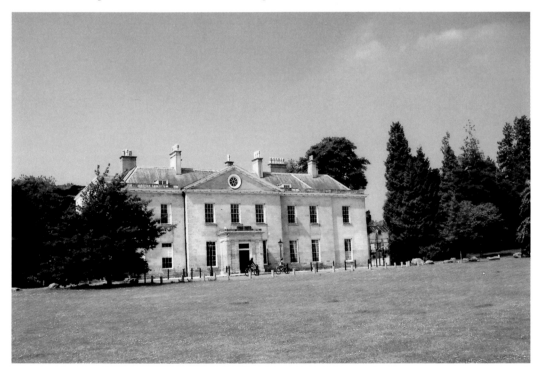

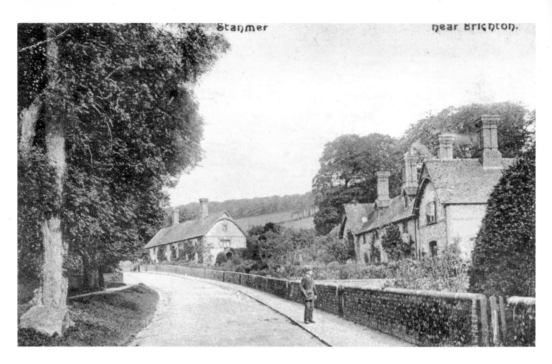

Stanmer Village

The first photograph was taken in around 1910. The present-day view is much the same apart from the bungalow infilling and parked cars. Loud bird-song can be heard but there are no longer the background noises of a working farm as the nearby farm buildings, yards and stables lie empty and shuttered.

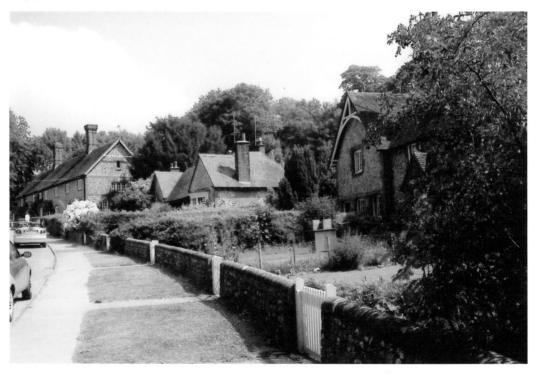

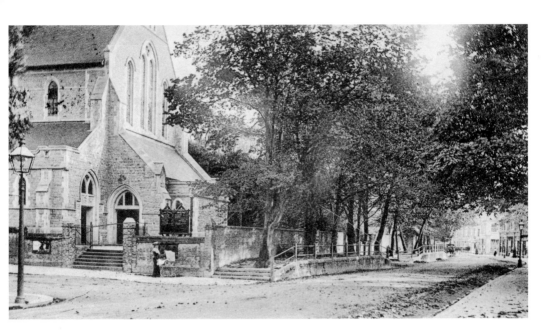

Preston Road and St John's Church

This is a lovely view of Preston Road when it was still a peaceful thoroughfare, but the elevated footpath has long since gone. The church of St John the Evangelist was built in 1902 to the design of Sir Arthur Blomfield. The first photograph was taken in 1904 when the church was still very new.

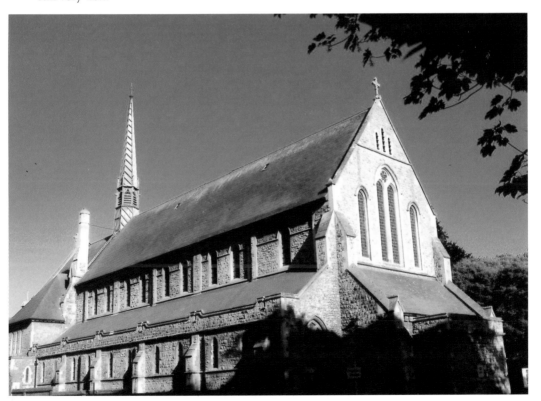

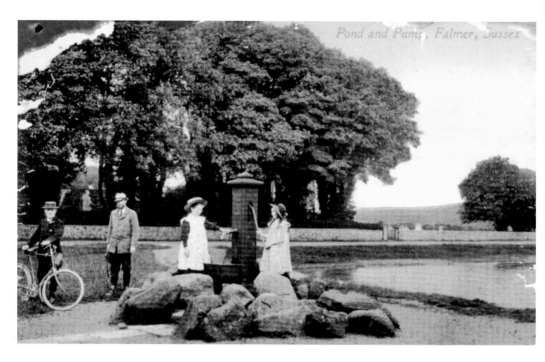

Falmer Pond

The two young girls enhance this picture of the village pump and pond. The presence of a photographer with his equipment was obviously an event worthy of attention by the male bystanders. Today, the pond is in excellent condition and it looks so peaceful that it is hard to realise that soon the roar of a football crowd will be heard from the new American Express Community Stadium built not far away.

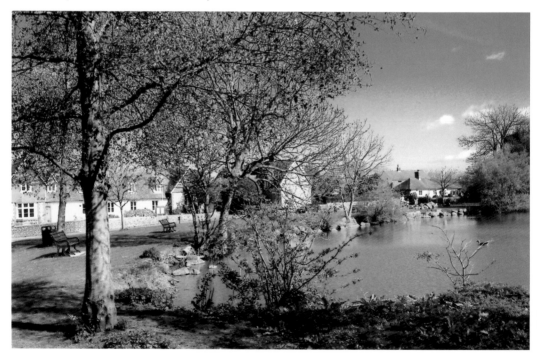

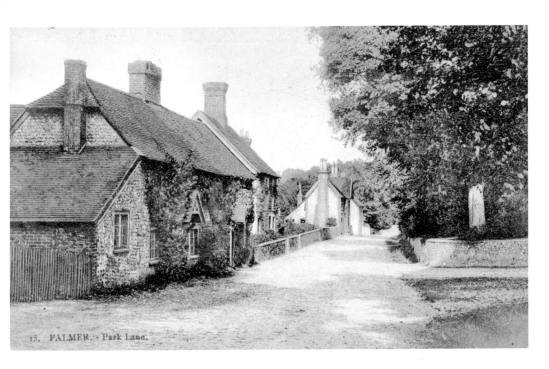

Falmer Village

This part of the village was previously known as Park Lane, but now it is Park Street. The flint cottages look much the same, although the one in the left foreground has lost a chimney-stack. Falmer was once part of the Stanmer Estate belonging to the Earl of Chichester.

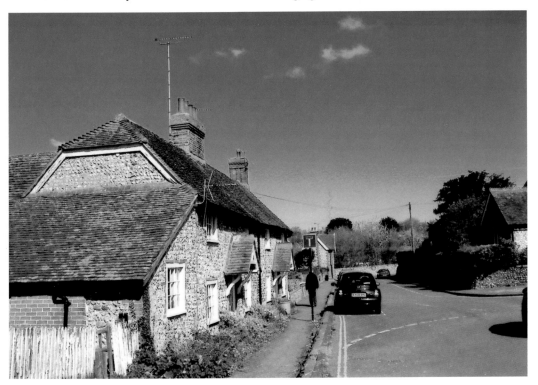

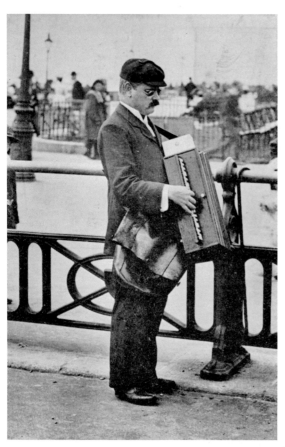

Blind Harry

Harry Elwes was known as Blind Harry and used to take his accordion to the seafront to entertain visitors. He is pictured standing just over the boundary in Hove. When he had finished his stint he would head to Preston Street and the New Pier Tavern where he displayed his skill at piano playing. Recently, a pub in Church Road, Hove, changed its name to the Blind Busker in honour of Harry Elwes.

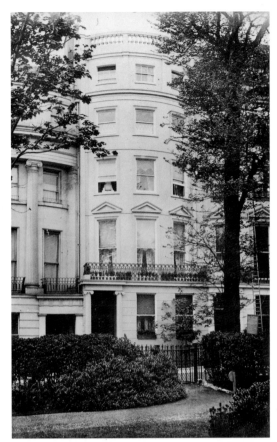

Brunswick Square

In this view taken in 1911, the railings emphasise that the gardens were for the private use of residents in the surrounding houses. It was only after the Second World War that Hove Council took control – they were obliged to, really, because the railings had been removed for war salvage. In recent years it became necessary to install new railings and ban dogs completely. Nowadays, families can sit on the grass without worry.

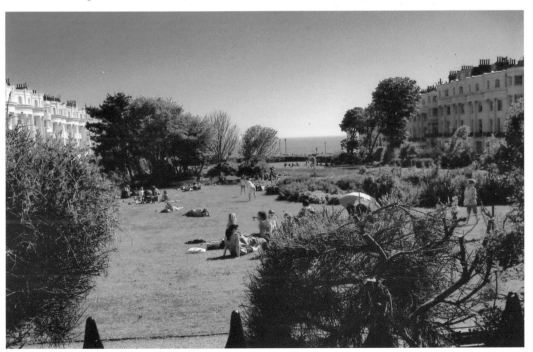

81

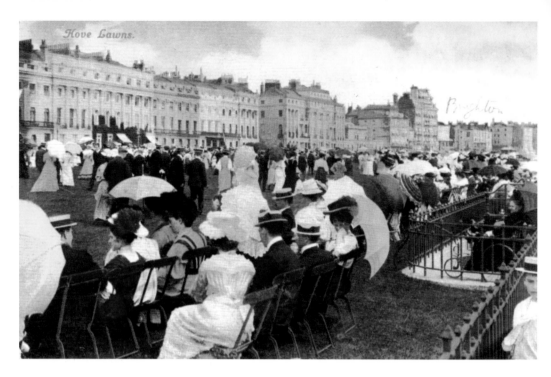

Brunswick Lawns

In Edwardian times, fashionable folk donned their best attire before promenading up and down Brunswick Lawns after church service on a Sunday. Today, the style of dress is irrelevant but the Lawns still make a great meeting place and venue for special events. The recent photograph was taken on 23 May 2010.

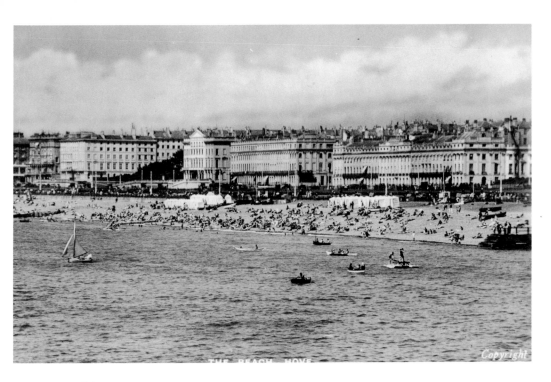

Brunswick Terrace

This unusual view reveals the symmetry of Brunswick Terrace and Adelaide Crescent when seen at a distance from the sea. No bathing machines are on view but there are tents for modest bathers. There are also more small boats than you would see today. In the recent photograph, the façades are in a good state of repair due to the law that requires the properties to be painted a uniform colour every five years.

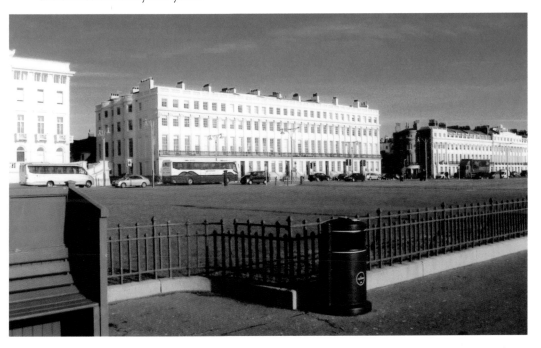

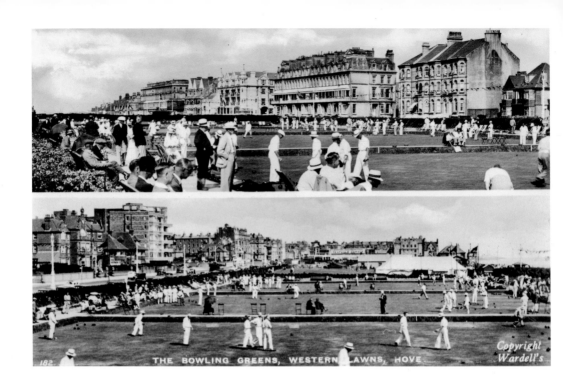

Bowling Greens

The double-shot postcard, taken in around 1937, finds all the bowling greens in active use. In the top one, the Sackville Hotel can be seen in the distance while in the lower one newly built Viceroy Lodge is on the left. The swimming baths have yet to be erected. The bowling greens enjoyed a good rest during the Second World War when this became a restricted area. The recent photograph was taken in June 2009.

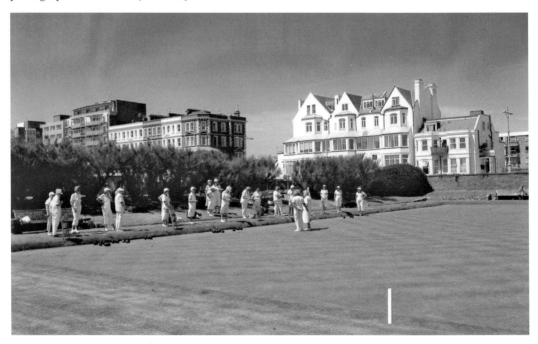

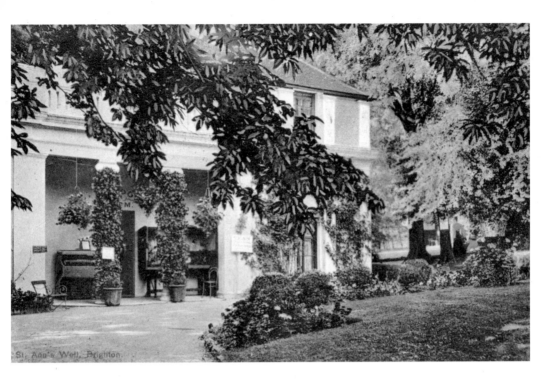

St Ann's Well Gardens

The Pump House enclosed the chalybeate spring whose slightly bitter waters brought many hopeful visitors to drink as a health tonic. Unhappily, it was demolished in the 1930s, the same decade in which Hove Manor was lost. The second photograph was taken at the well-attended Spring Festival on 22 May 2010, with the Brighton School of Samba in performance.

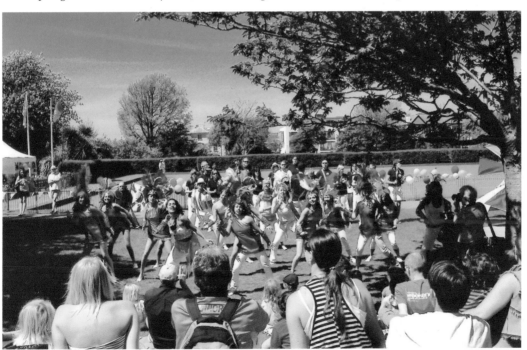

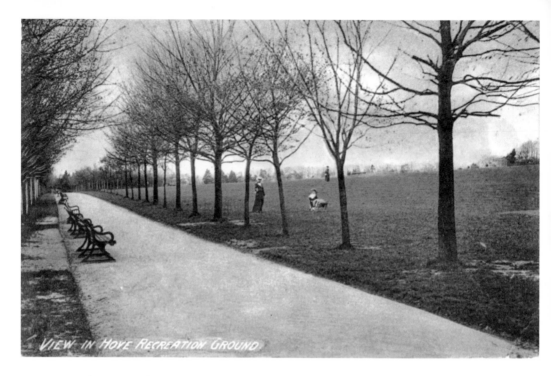

VIEW IN HOVE RECREATION GROUND

Hove Recreation Ground

The top view dates from 1908 when there were many benches lining the pathway. By contrast there is only one there today. In the 1990s, an enormous controversy was raised by Hove Rugby Club's plans to move there and create four rugby pitches plus a clubhouse. There were protests, petitions, banners, stormy council meetings and restrictive covenants were quoted. Celebrities such as Chris Ellison, Michael Jayston and Chris Eubank were involved in the campaign. But all to no avail.

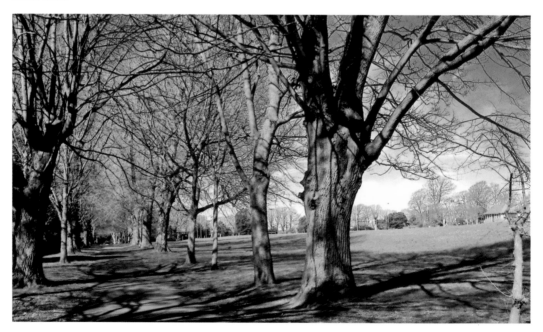

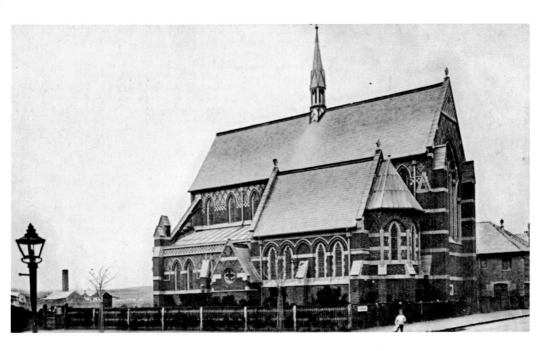

St Philip's Church

The exterior of the church must rank as one of the most colourful in Brighton and Hove, with its wealth of red brick, knapped flint, Bath stone and grey limestone in geometric patterns. The church was extended in 1909/10 and the join can be clearly seen in the roof tiles. To the north is Lion Mews where, in 1891, some fifty people were living, including five coachmen, a cabman, a blacksmith and a gardener with their families.

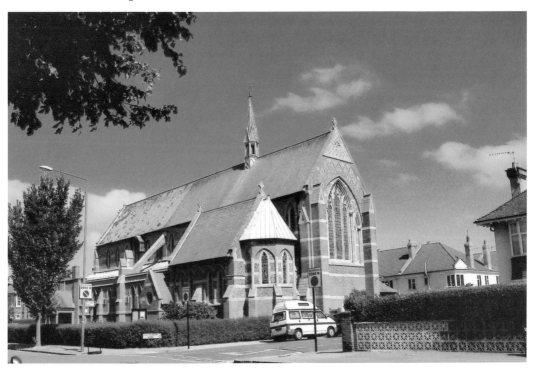

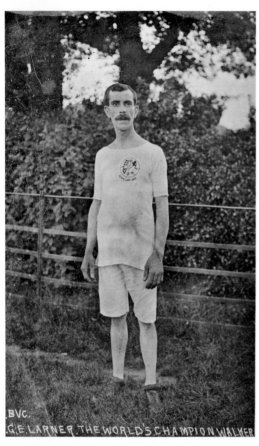

BVC.
G.E LARNER THE WORLD'S CHAMPION WALKER

A Champion Walker and the Brighton Marathon

George Larner was a very fit Brighton policeman whose chief constable was accommodating enough to allow him time off for training. In the 1908 London Olympic Games, Larner won a gold medal for the 10-mile walk and a gold medal for the 3,500-metre walk. The second Brighton Marathon was held on 10 April 2011 and there were around 8,000 runners. The second photograph shows the turning point in New Church Road, Hove.

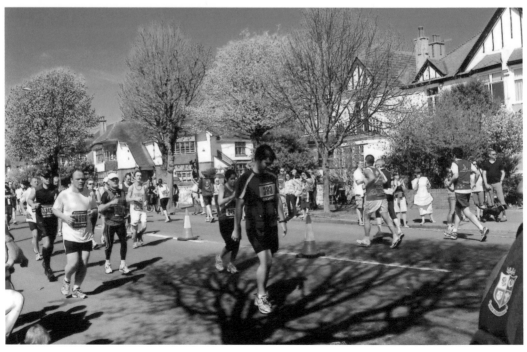

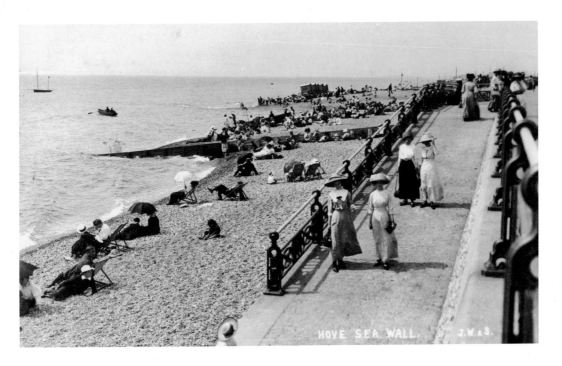

Hove Seafront and the Brighton Marathon

This wonderfully sedate image of Hove beach is made more poignant by the fact that it was posted in 1913, just months away from the horrors of the First World War. Runners in the Brighton Marathon of 2011 are shown passing the Blue Lagoon pub near the 20-mile mark, some sprinkling water over their heads to cool themselves. The route continued to the power station, then back along Hove seafront and on towards the finishing line at Madeira Drive.

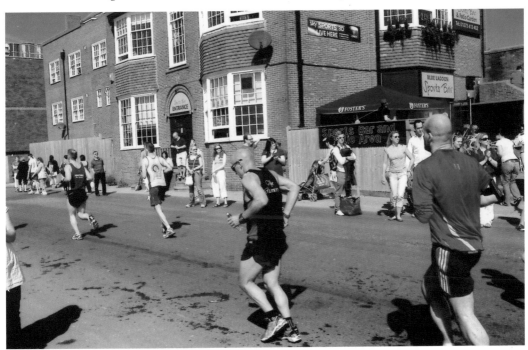

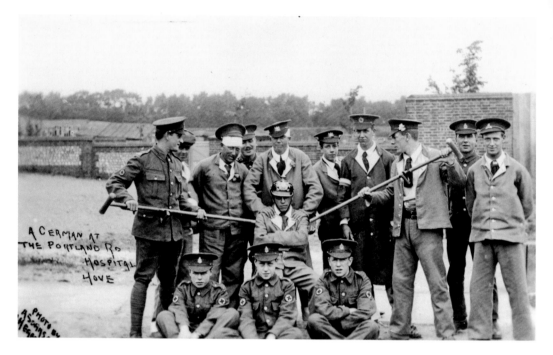

Wartime Hospital

Portland Road schools served as a military hospital from June 1915 to May 1919 and were a branch of the Second Eastern General Hospital. The establishment included outside wards for TB cases. The postcard shows patients larking about, but the one in the trophy German helmet seems fittingly serious. The wall in the background is not the same as the one seen in the second photograph of the school but resembles the flint wall at Hove Cemetery.

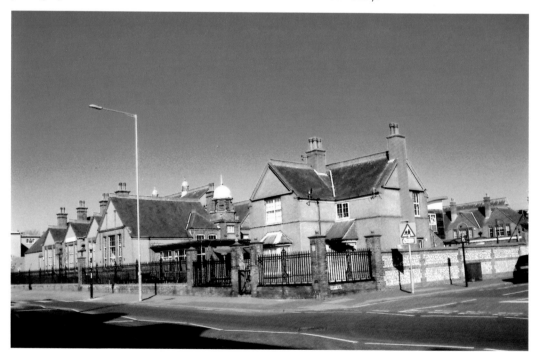

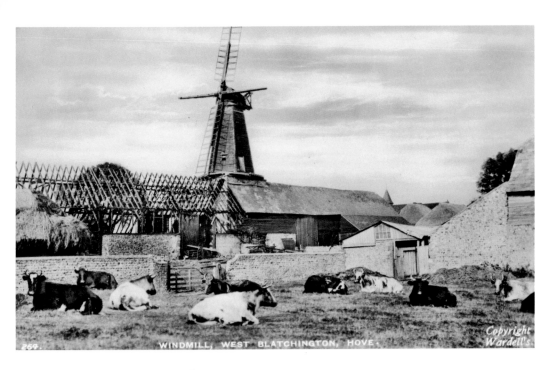

West Blatchington Windmill

The cattle seem oblivious to the destruction apparent behind them. The photograph was taken in the wake of the fire that erupted on 3 May 1936 and destroyed the barn on the south side. Had the wind not been blowing from the north-east, the windmill would have gone too. The second view was taken on a busy Open Day on 18 July 2010. Three months later, two of the sails were removed because of decay.

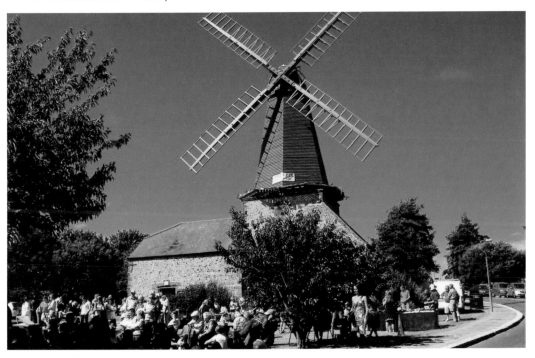

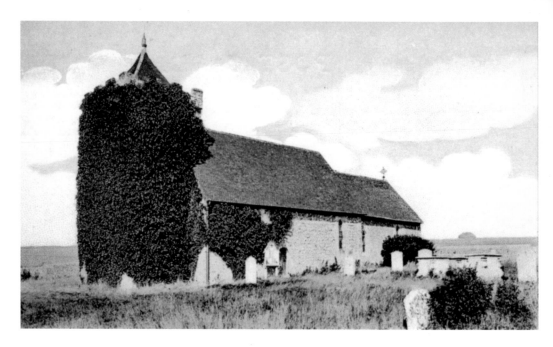

St Helen's Church, Hangleton

The remote location of the church helped to preserve its medieval identity, but by the 1870s it was in a neglected state. Fortunately, Sir George Cokayne financed repairs. The ivy-covered tower, such a romantic trait for Victorians, was long a feature of the building. Modern thought considered ivy to be detrimental to the fabric; however, recent research shows that, in fact, ivy acts as a layer of insulation while at the same time protecting the building from the weather.

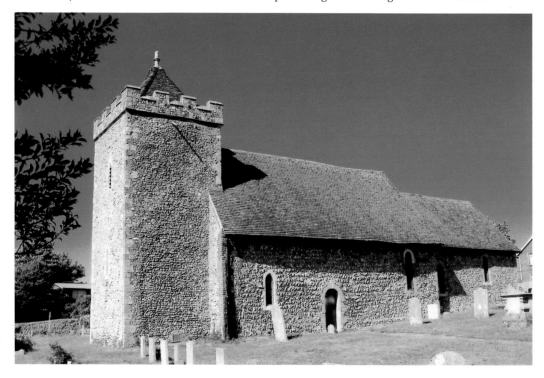

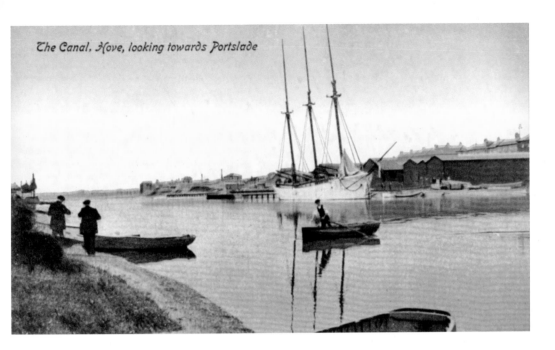

The Canal, Hove, looking towards Portslade

Aldrington Basin and the Canal

It was a day without wind when the postcard view was taken with the small ferryboat crossing tranquil waters. But it was not always thus and treacherous crosswinds could make this short stretch of water dangerous. The ferry took workers across to the gasworks, saving them a long walk around Aldrington Basin. The second photograph, taken in June 2010, is of two of the boats that fish local waters moored at the quay.

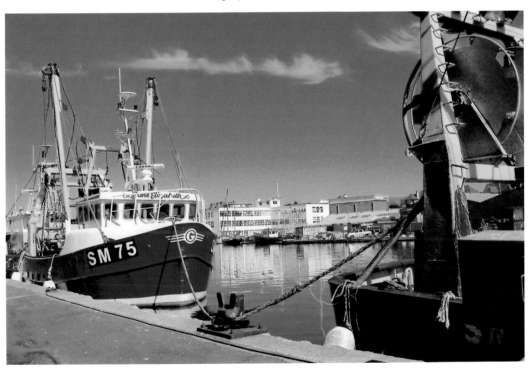

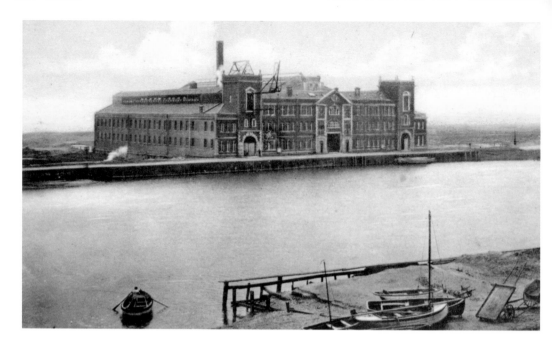

Power Stations

The first photograph was taken shortly after the electricity works opened in 1906. No doubt it was a marvel of efficiency but one cannot help wondering how many people would actually want to purchase a postcard of it. It is interesting to note that, although the superstructure has long gone, the modern plant still utilises the old cable tunnel constructed under the canal. The new power station opened in 2004 and cost £150 million.

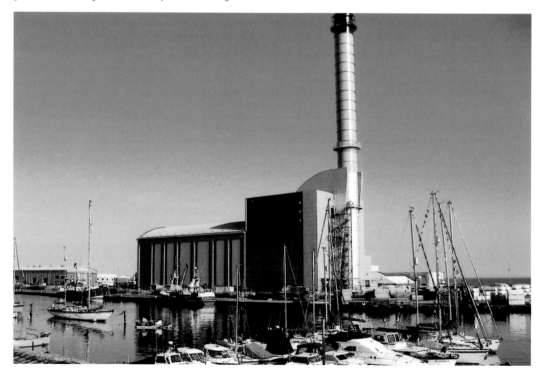

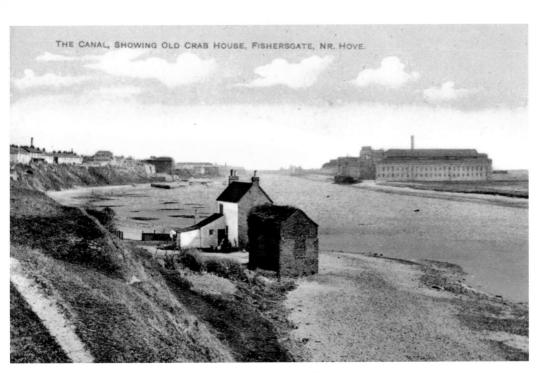

The Canal looking East

The Crab House in the foreground was famous for its crab teas, and the story goes that one satisfied customer was William IV who liked to visit while staying at the Royal Pavilion. Other stories relate that an underground tunnel ran northwards from the basement of the Crab House and, of course, the area was notorious for its smuggling activities. This was why the Coastguard station was built at Hove.

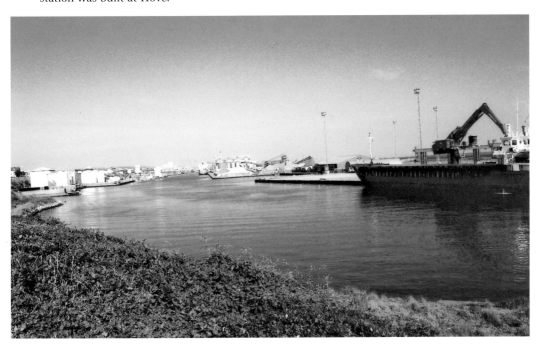

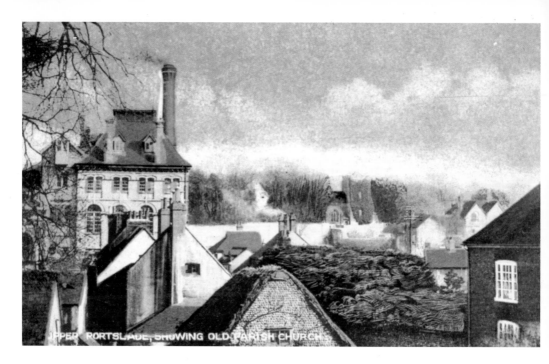

UPPER PORTSLADE, SHOWING OLD PARISH CHURCH

View Across Portslade Old Village

The old view is dominated by the lovely roofline of the Brewery building. It is such a pity that it was removed when an extra storey was added. The sea of cypress trees in the foreground stood in the garden of Portslade Grange – visible on the right. The church tower and Whychcote appear in both photographs. The recent view was taken from an upstairs window in High Close and Manor Lodge, and the village green can just be seen.

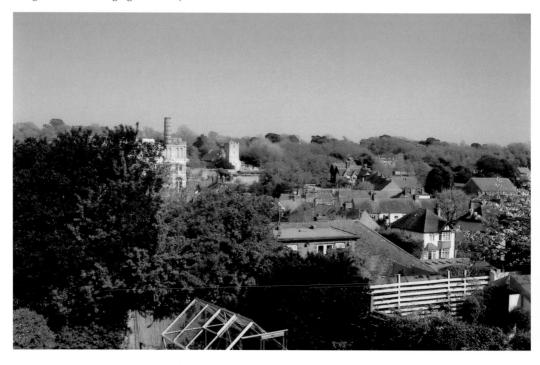